FLEETWOOD & THORNTON CLEVELEYS

THROUGH TIME

Peter Byrom

AMBERLEY PUBLISHING

I would like to dedicate this book to my wife Audrey for her patience and understanding, and for suffering long periods of silence while I compiled it. I would also like to dedicate this to my daughter Alison, her husband David, my grandchildren Daniel and Lauren, and my great-grandchildren, Megan Skye and Sophie Rae.

First published 2013

Amberley Publishing
The Hill, Stroud, Gloucestershire, GL5 4EP
www.amberley-books.com

Copyright © Peter Byrom, 2013

The right of Peter Byrom to be identified as the
Author of this work has been asserted in accordance with
the Copyrights, Designs and Patents Act 1988.

ISBN 978 1 4456 2149 4 (print)
ISBN 978 1 4456 2155 5 (ebook)

British Library Cataloguing in Publication Data.
A catalogue record for this book is available from the
British Library.

Typesetting by Amberley Publishing.
Printed in Great Britain.

Introduction

Like my first two books *St Annes Through Time* and *Lytham, Fairhaven & Ansdell Through Time*, I do not propose to write a detailed history of the areas covered by this book, just a brief outline, leaving the pictures to tell the story.

Fleetwood

At the age of twenty-four, Peter Hesketh inherited a large area of ground along what is now known as the Fylde Coast. There were a few small villages with whitewashed cottages dotted about, as well as some isolated dwellings, but the main attraction for Peter was the barren area of land, full of rabbit warrens and sandhills, at the northern end of his inheritance, where the River Wyre opened up into the Irish Sea. Here, he envisaged building a port with a fashionable seaside resort next to it but the key to its success was getting the railway system from Preston extended to the area. There was some opposition from Preston inhabitants because they thought it would harm trade at their port and consequently lead to job losses. The first sod for the future Fleetwood was cut in 1836 and, despite the opposition, a single line railway was completed in 1840, costing more than double the original estimate. From this point, Fleetwood started to grow rapidly.

Peter Hesketh originally employed Decimus Burton to design the port and town, which he did using Tup Hill – the last large sandhill along the coast – as its central point. He called it the Mount and used it as the axis. The town was designed in the shape of a wheel, with all the roads radiating from it like spokes. Peter also employed Frederick Kemp as his Steward to look after his affairs. Kemp opened a builders' yard where Kemp Street now is, and supplied goods to various enterprises going on in the town on what today would be classed as dubious contracts. If the builder got into debt with him and failed to pay, the ownership of the building in progress fell to him. He then paid the builder to finish it. He gained numerous properties in this way, most notably the Crown Hotel, opposite what was to become the main entrance to the first railway station in the town, called the Wyre Dock railway station. The Crown Hotel operated in direct opposition to Peter's North Euston Hotel, a short distance away up a cart track.

Following funding for the railway and further developments, Peter gained a knighthood in 1838 and also added Fleetwood to his name to become Sir Peter Hesketh Fleetwood. Putting too much trust in his so-called friends and advisors and signing cheques too readily without checking invoices, he soon found himself in financial difficulty and started having to sell off parts of his estates to pay some of his debts. One of the main buyers was one Frederick Kemp, his steward. Things went from bad to worse, and he had to lease out his ancestral home Rossall Hall after selling most of the contents in a sale that lasted two weeks, enticing buyers from as far away as London. Disillusioned, Sir Peter left England with his second wife and son Louis (his first wife and children had sadly

passed away), and ended up living in Naples where the cost of living was cheaper and he could barter for his food.

Fleetwood's future then passed to a group of town commissioners. The port prospered in all aspects and over the next 100 years it became one of the biggest fishing ports in the country. By the 1980s and '90s, following the Cod Wars with Iceland, the imposition of restricted fishing grounds and the EU's meddling in fish quotas, it took only ten years to destroy the port, with hundreds of people losing their livelihoods. The holiday industry suffered when a branch line was opened to Blackpool in 1846, which offered better beaches and cheaper accommodation, and the situation worsened when Dr Beeching closed the railway line to Fleetwood in 1966. Sir Peter was not bankrupt when he died in 1866, but his son Louis, a priest inheriting, was declared bankrupt eight years later. When he died unmarried in 1880, the baronetcy ended. Lady Fleetwood died in 1900; after being found by a great nephew living frugally in Haywards Heath, she had been taken to live at what is reputedly Britain's most haunted house – Wyerming Manor – in Portsmouth.

Before Fleetwood had its own church or graveyard, the people of the town were interred at Thornton parish church.

Thornton Cleveleys

Most of the towns as we know them along the Fylde Coast have at least one thing in common: they have not evolved over the centuries into the towns we know today, but instead they are products of the last couple of hundred years – isolated hamlets and whitewashed cottages with thatched roofs dotted around inland from the stormy coastline. Thornton as a village was listed in the Domesday Book as Torentum.

A railway station was established here in 1865 on the line from Preston to Fleetwood, opening up the coastline of Cleveleys, less than two miles away, by coach and horses.

Cleveleys

Cleveleys (formerly called Ritherholm, a name derived from the rivulet that entered the sea here) was once a desolate area. A big surge of the sea in 1555 destroyed the Forest of Amounderness, and villages such as Singleton Thorpe in Cleveleys and Kilgrimol in St Annes, were never to fully recede again. The cottages that were dotted around the Fylde were built in the wattle and daub fashion and their roofs were supported by crucks (a curved wooden beam), many of which were from the timbers of the ships that were wrecked along the coast here and eagerly plundered by the locals. After the lighthouse was built at Fleetwood, the number of shipwrecks decreased. The coastal erosion was so constant that houses, farms and land along the coastline were being lost to the sea at an alarming rate, including Old Ross Hall in 1820. This was not helped by the removal of wagon loads of boulders, rocks, pebbles and shingle (the natural sea defence) by the locals to build roads and walls, and sea defences had therefore to be constructed. The promenade has undergone numerous changes since the early 1900s and the latest multimillion-pound sea defence was completed in 2011.

Thornton and Cleveleys amalgamated in 1927.

Peter Byrom, 2013

Fleetwood

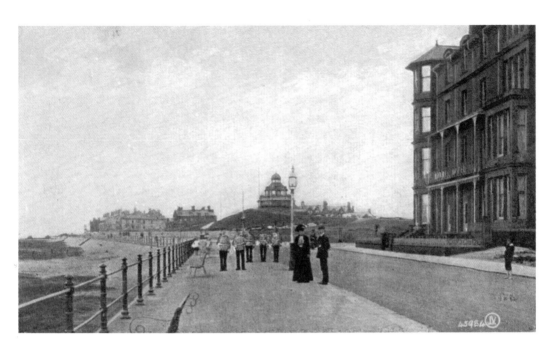

Fleetwood Seafront
The refurbished promenade is pictured here with the Mount in the middle and Mount Hotel on the right. The seafront was not yet established. Fleetwood was frequented by wealthy visitors after the arrival of the railway.

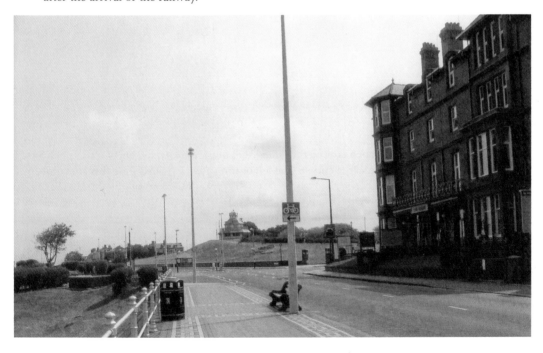

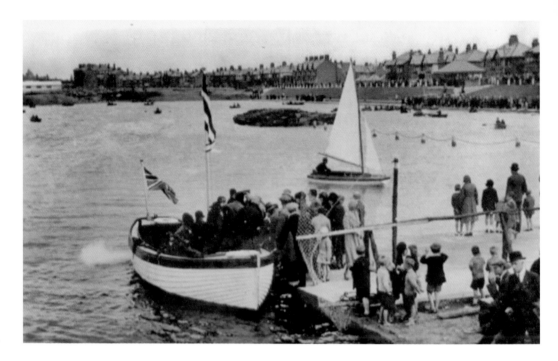

The Boating Lake, Laidley's Walk

A very busy time on the boating lake, situated on Laidley's Walk at the far end of the seafront. The island in the lake is known locally as Robin Crusoe Island. Next to it is the model boating lake, the home of the Model Yacht and Power Boat Club, which opened in 1932 and is a popular venue for children and adults alike. The Model Boat World Championships have been held here in the past. The level of the water was low when the modern photograph was taken, as a result of maintenance and the renewal of fifty-year-old valves that control the water pumped from the sea to fill the lakes.

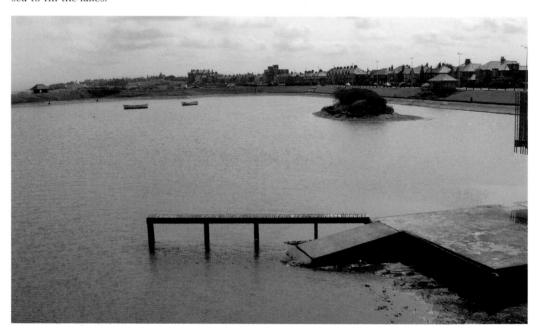

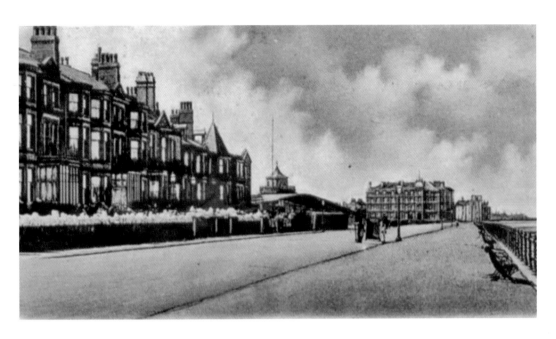

Fleetwood Promenade
The postcard states that this is a view along the promenade; it is now known as the esplanade after an outer promenade was built along the seafront.

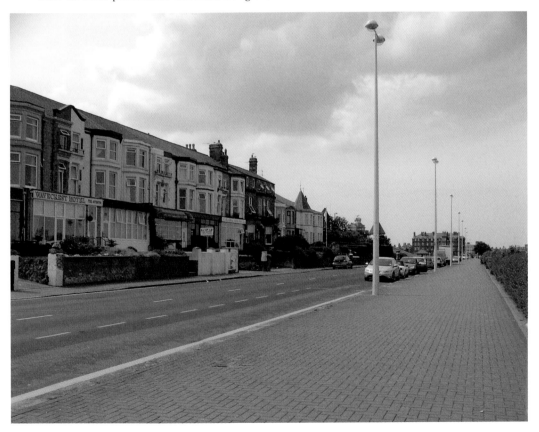

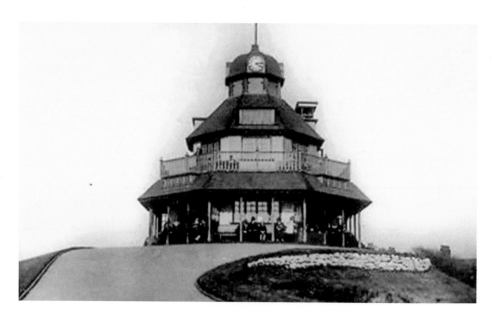

The Mount

The Mount, the axis of Decimus Burton's planned layout for the new town of Fleetwood, was the last large sandhill along the coast, which was originally called Tup Hill. The first building erected upon it was in the style of a Chinese pagoda known as Prophet Place or Temple View. It was replaced by the present pavilion, and James Robertson presented it with a clock and anemometer in memory of the Fleetwood men who lost their lives in the First World War.

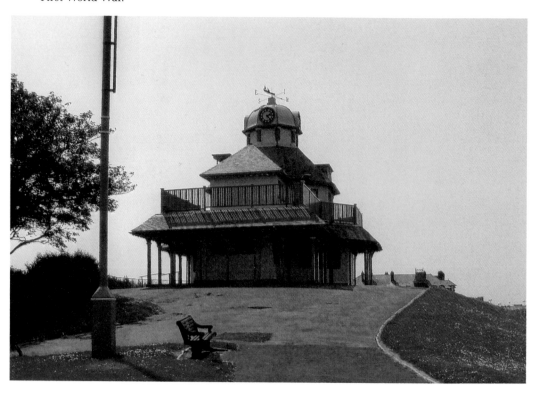

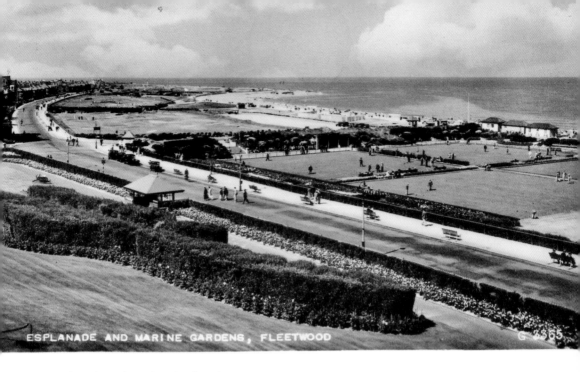

ESPLANADE AND MARINE GARDENS, FLEETWOOD G 3365

Esplanade and Marine Gardens I

A panoramic view of the Irish Sea from the Mount. In the foreground is the esplanade and Marine Gardens situated between the esplanade and outer promenade. Promenade Road runs from the esplanade to the buildings on the outer promenade and past the Mount Hotel, separating the bowling greens from the miniature golf course.

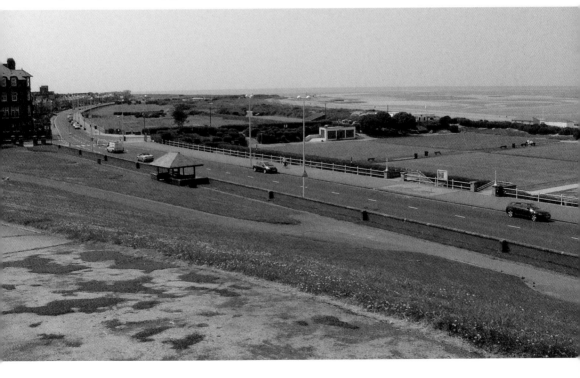

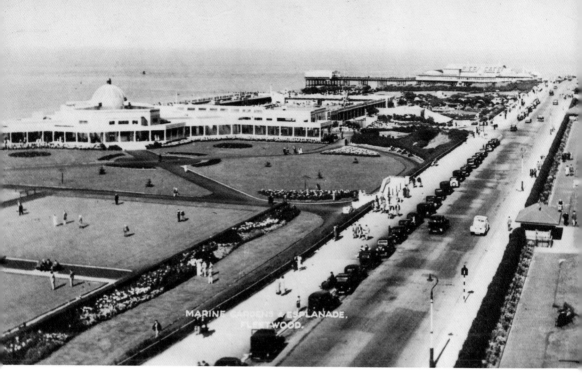

Esplanade and Marine Gardens II
The opposite view of the esplanade and Marine Gardens from the Mount. More vehicles parked along this stretch because of its proximity to the Marine Hall, open-air baths and the pier.

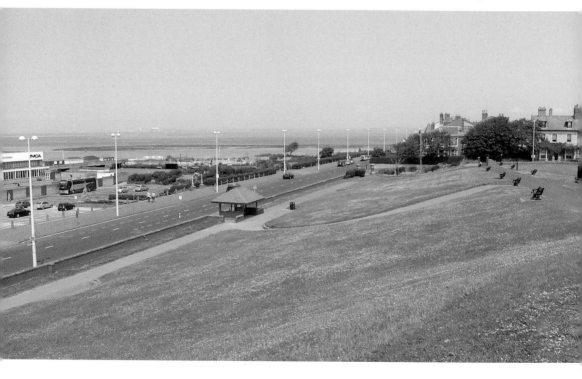

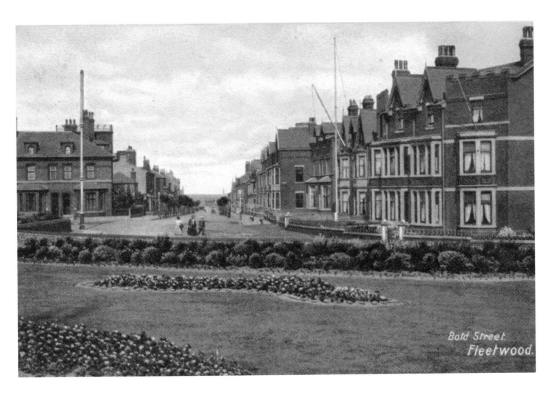

Bold Street

The road running behind the Mount is called Mount Road. The photographs on this page stretch across the road, looking down Bold Street, towards the Knott End ferry terminal. The small building in the middle of Bold Street is still there selling Fleetwood rock.

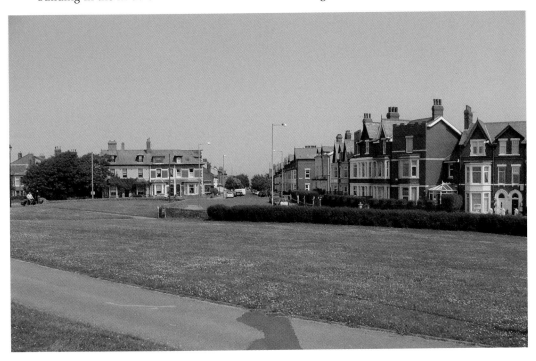

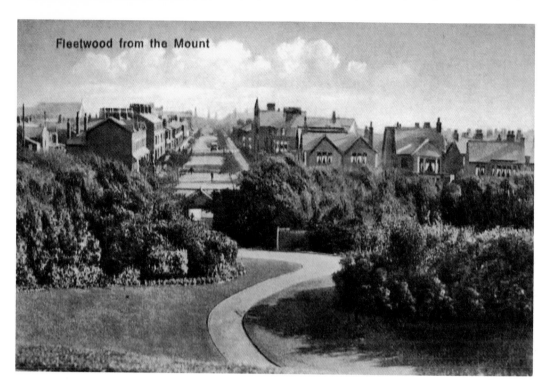

Fleetwood from the Mount
This view from the Mount looks along London Road towards the banks of the River Wyre, a short distance away from the docks and original railway station on the right.

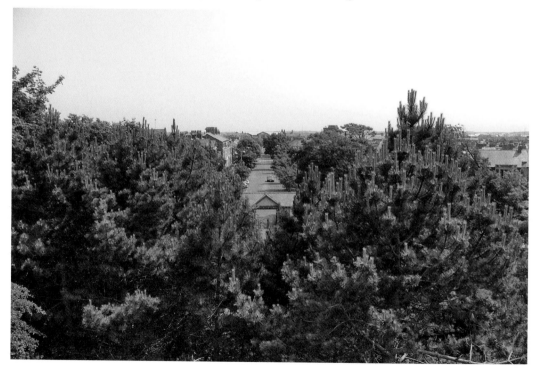

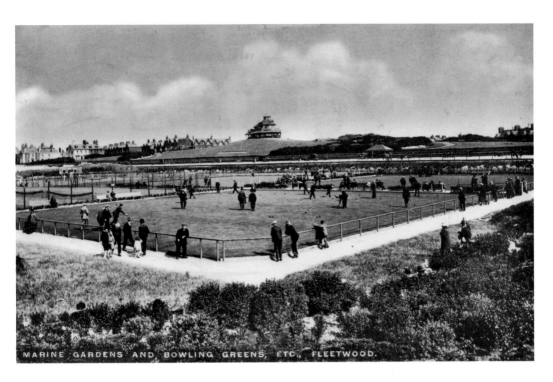

MARINE GARDENS AND BOWLING GREENS, ETC., FLEETWOOD.

Marine Gardens Entertainment

This shows some of the entertainment available in the Marine Gardens and along the seafront. Other entertainment included a model boating lake and a miniature golf course. Bowls is still a popular hobby today, with the area hosting many tournaments.

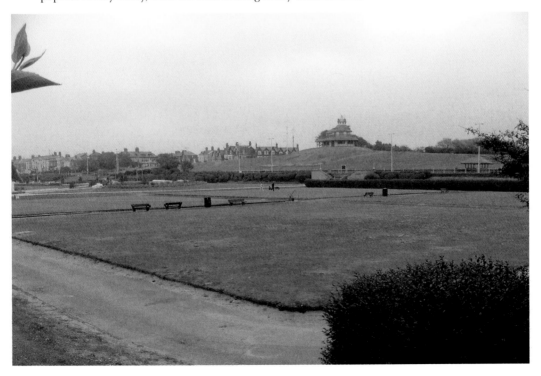

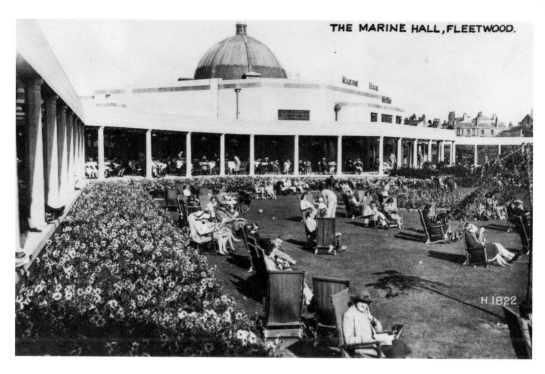

THE MARINE HALL, FLEETWOOD.

H.1822

Marine Hall

Marine Hall, sitting proudly on the seafront, is a popular venue for a variety of entertainment all year round. The hall and gardens in front were transformed in 2011/12 to create a modern outdoor entertainment area, with a semi-circular grassed area as the auditorium.

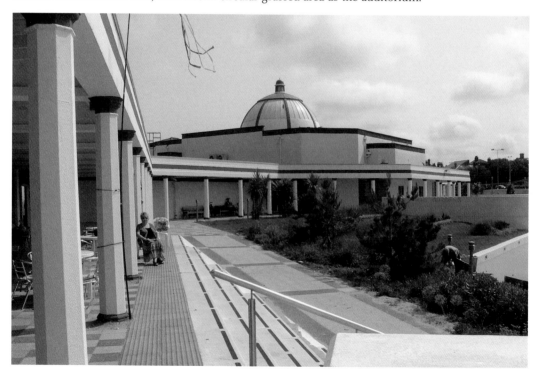

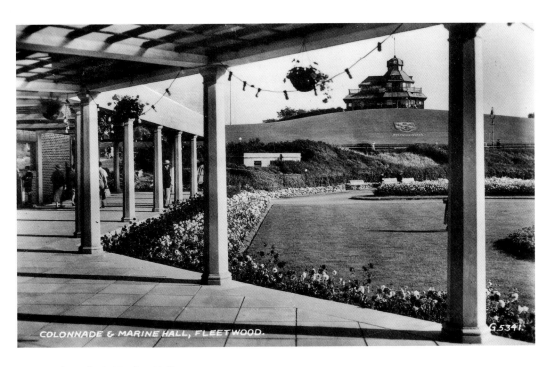

Colonade & Marine Hall
The modern view of the colonnade attached to the Marine Hall complex shows the outdoor stage area, created in the recent refurbishment.

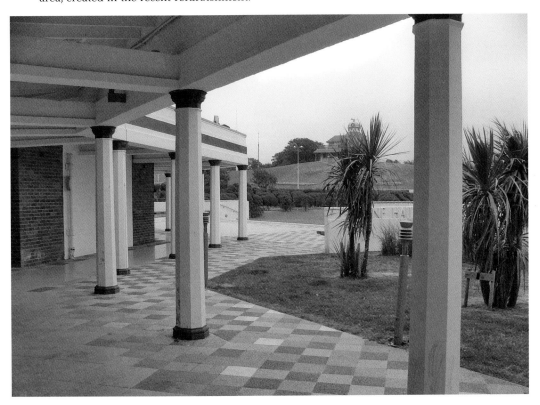

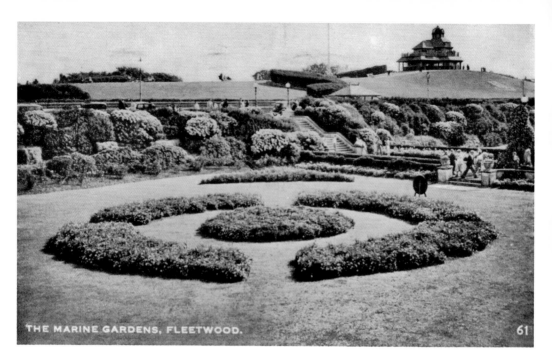

THE MARINE GARDENS, FLEETWOOD.

61

Marine Gardens 1

The gardens by the Marine Hall. The curved hedge on the Mount has now been removed but the path in front is still there. The shrubs have disappeared and the steps have been replaced by a tarmac road leading to the car parks.

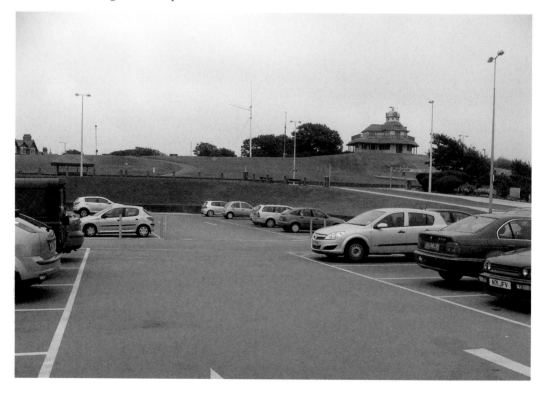

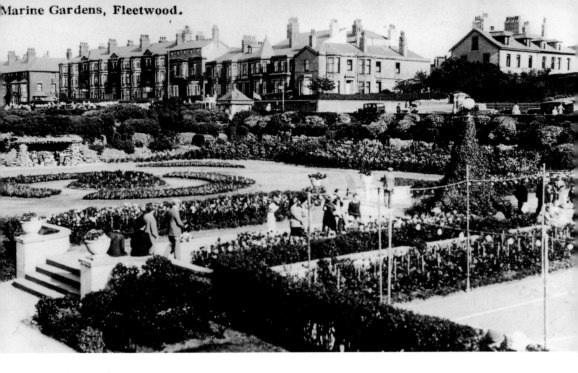

Marine Gardens II

This view of the Marine Gardens is taken from nearly the same place as the photographs seen on the previous page, but this time looking to the left. Marine Gardens were replaced by car parks for the Marine Hall and Fleetwood Leisure Centre and Swimming Pool complex, which were built on the site of the open-air baths.

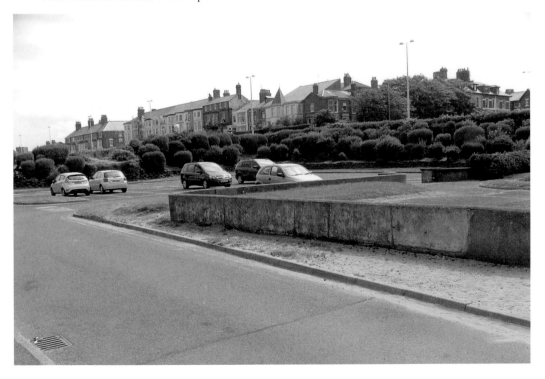

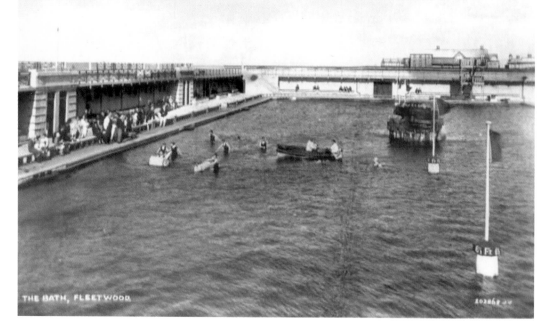

Open-Air Baths
The open-air baths were created in 1925, when the seafront was undergoing development. Their popularity declined after the Second World War, and unfortunately it disappeared under bricks and mortar in 1974 to form what is now the popular Fleetwood Leisure Centre.

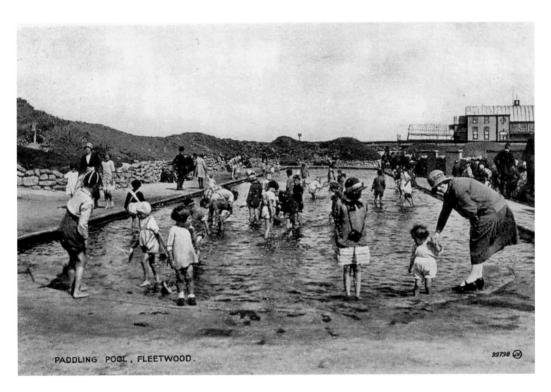

PADDLING POOL, FLEETWOOD.

Paddling Pool
The children's paddling pool is still just as popular today, while beach huts now occupy the area of sand dunes.

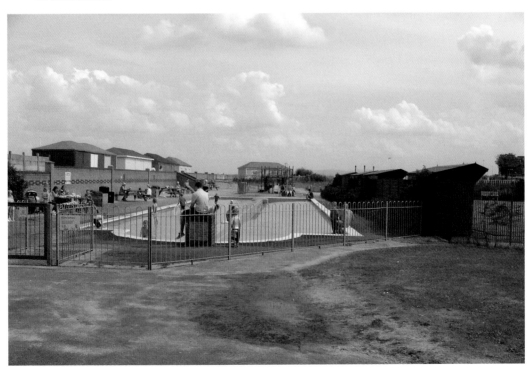

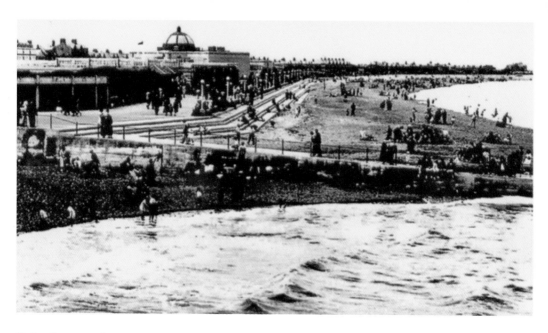

Outer Promenade

A view of the outer promenade and the much-visited pebbly beach at high tide, showing the domed Marine Hall.

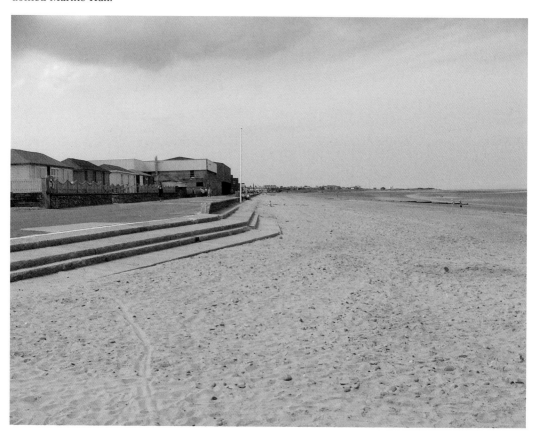

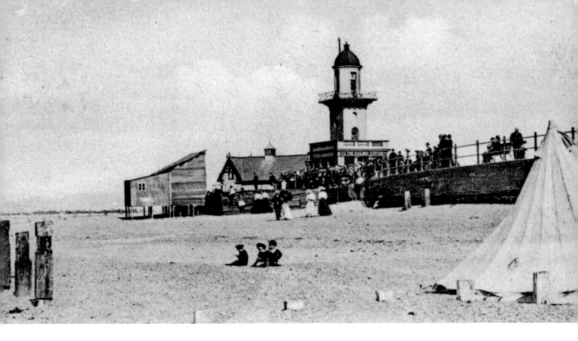

Camping on the Beach
Camping on the beach at Fleetwood, with the lifeboat station situated behind what is known as Lower Lighthouse (*centre*). I wonder what was happening at sea that was so interesting to visitors.

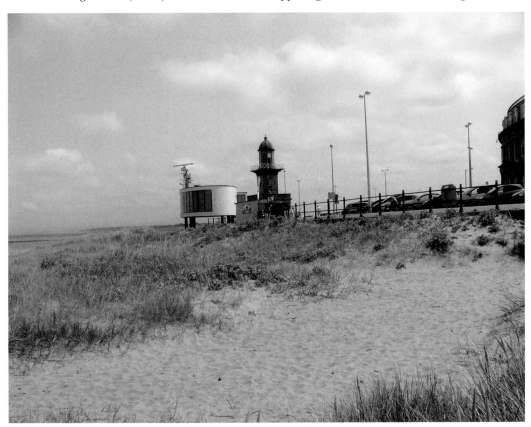

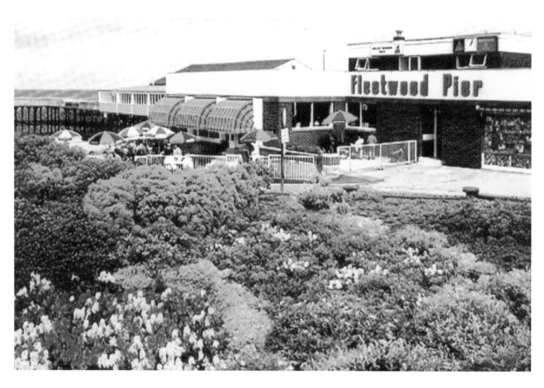

Jolly Roger Rose Garden

Next to the pier lies this floral display called the Jolly Roger Rose Garden, named after the building behind it that was part of the pier complex and known as the popular Jolly Roger Bar.

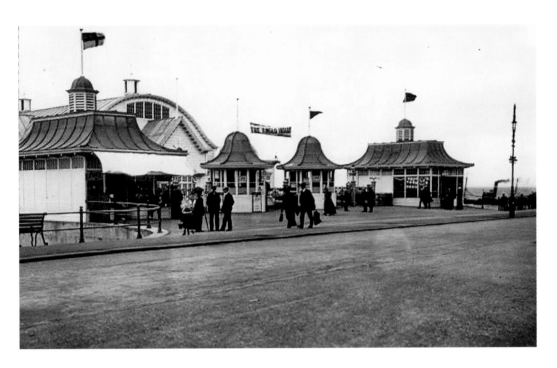

Fleetwood Pier

Fleetwood Pier, also known as Victoria Pier, was built in 1910 and was probably the last pleasure pier to be built in the United Kingdom. It was badly damaged by fire in 1952 and reopened in 1958. From this point on, it had a chequered history, until 2008, when it was again destroyed by fire, leading to its total demolition. Controversial plans for a two-storey, eighteen-bed hotel to be built on the site were passed in 2013.

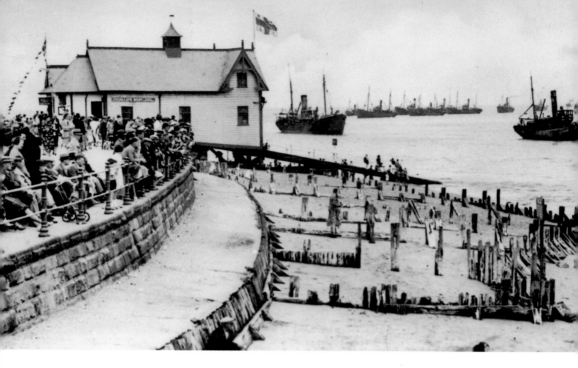

Trawlers Returning to Port

Crowds welcome the trawlers returning to port on calm seas from the deep-sea fishing grounds, where they had been fishing for up to three weeks. (The families did not wave them goodbye at the start of their trip as it was considered unlucky.) The message on the back of the card is dated 27 July 1938 and reads, 'We sat on the beach last evening watching these trawlers coming in, there were 14 of them, it was a beautiful sight, and they were followed by the Lady of Mann.'

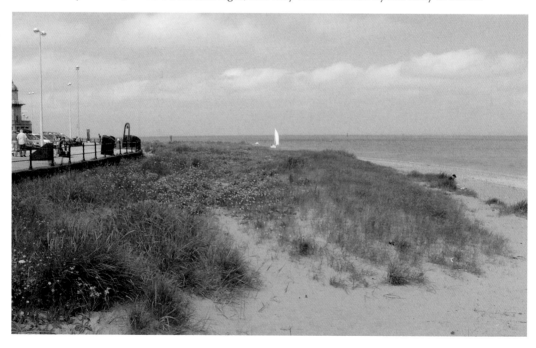

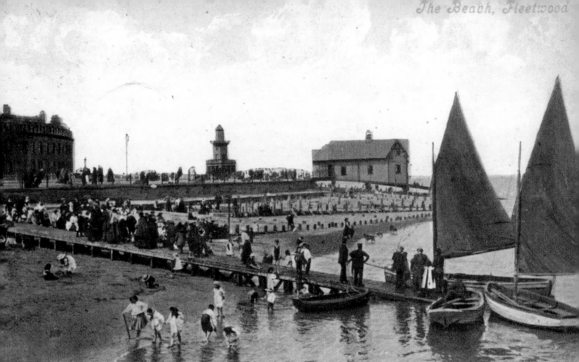

The Beach

The postcard above is stamped 1909 and shows happy times on the beach, with North Euston Hotel on the left, Lower Light in the middle, and the lifeboat station on the right. The statue (*see inset*) called Welcome Home, sculptured by Anita Lafford, is positioned on the promenade where the wives and children assembled to watch and welcome the safe arrival of the trawlers carrying their husbands and fathers back home, as seen in the previous picture. It was unveiled in 1997.

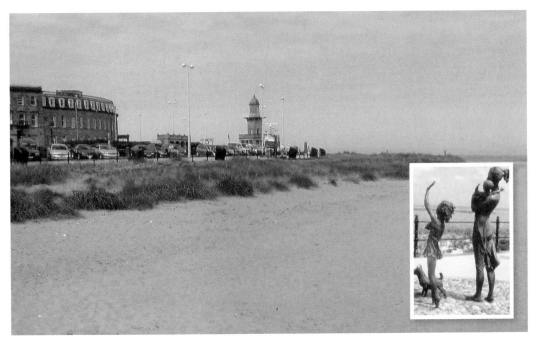

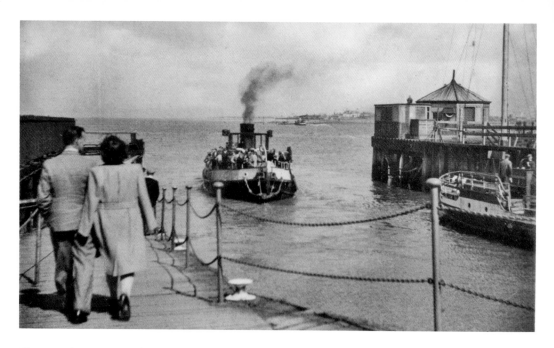

Fleetwood to Knott End I

The crossing from Fleetwood to Knott End was at one time carried out by boats propelled by oars or sails. Steam ferries then arrived, making the crossing easier, and over the years numerous boats were used such as the *Onward, Progress, Bourne May, Wyresdale, Calderdale, Viking,* and the one pictured here, which I believe is the *Lunevale*. When she retired, she was left to rot and eventually taken out and scuttled off Knott End, opposite Wyre Light, which is reachable by foot at very low tide.

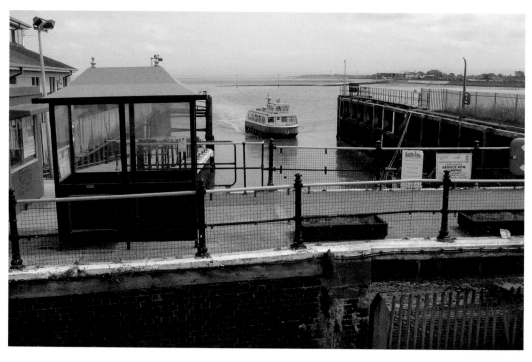

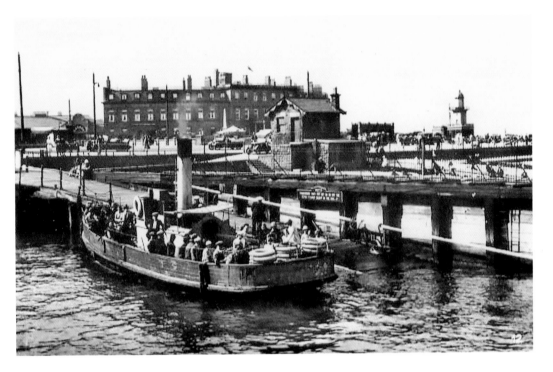

Fleetwood to Knott End II

Another Knott End ferry being embarked at Fleetwood (*above*). The small square building in the middle is still there and is the same one that can be seen at the bottom of Bold Street when viewed from the Mount. In 1890, it was proposed a new seaside holiday resort would be established at Knott End where the beaches were bigger and more child friendly than Fleetwood. It was also suggesed that its name should be changed to St Bernards-on-Sea or Sunset Bay, to which the locals objected.

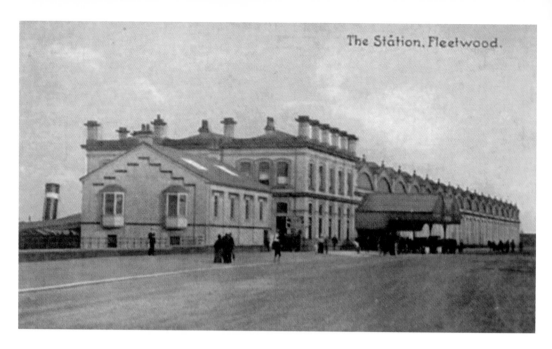

The Station, Fleetwood.

Fleetwood Station !

There have been two railway stations in Fleetwood. The first single line track, arriving in 1840, ran on an embankment and trestle bridge over the boggy Wyre Estuary, and terminated in Dock Street (opposite Church Street and Frederick Kemps Crown Hotel). It was called the Wyre Dock railway station. The first train arrived to great merriment and revelry, but, unfortunately, on the return journey to Preston, one of the drunken revellers, while trying to change carriages, fell off and was decapitated. In 1846, when the trestle bridge became unsafe, the line was re-routed on safer ground a bit further inland, and at the same time a branch line was opened to Blackpool, which offered better beaches and cheaper accommodation.

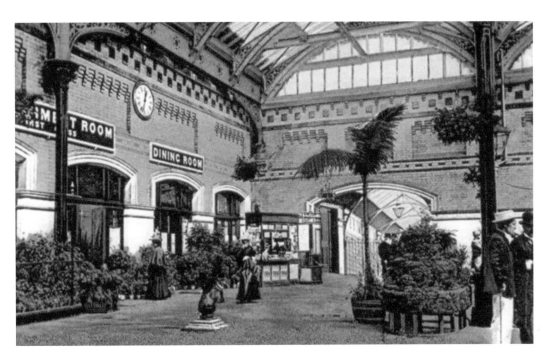

Fleetwood Station II

With the arrival of the railway, there was an upsurge of visitors both rich and poor to the area. The line was extended in 1883 to Burtons Houses, which were renamed Queens Terrace after Queen Victoria's visit in 1847, and the new station was called Fleetwood. The sumptuous waiting hall offered first and second class refreshments rooms and a glass-roofed arched tunnel down to the dockside, where waiting ships would take customers onward to Ireland, the Isle of Man and Scotland. The usage of the station declined over the years and in 1966, despite much opposition, Dr Beeching ordered its closure. It was immediately demolished.

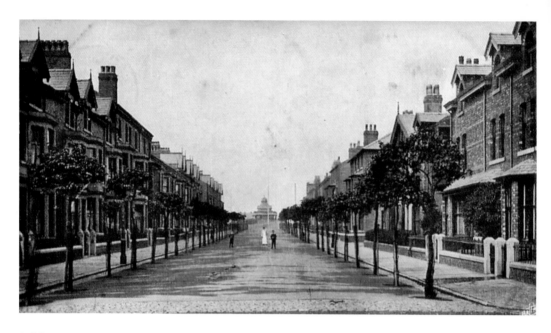

Bold Street
Bold Street as seen from the junction of Church Street and North Church Street. Fleetwood's hospital is to be found on Bold Street.

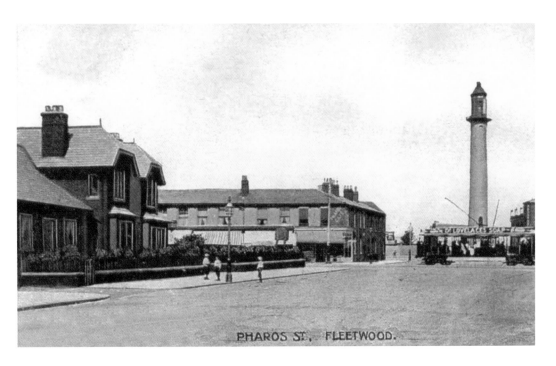

PHAROS ST., FLEETWOOD.

Pharos Street

Fleetwood is the only town in Great Britain to have had three lighthouses. Pharos (Upper Lighthouse), at 93 feet tall, and Lower Lighthouse, at 44 feet tall (both designed by Decimus Burton), opened in 1840, and the Pharos was rebuilt in 1906. Ships coming into port lined the lighthouses up for guidance and safe passage. For many years, two of the lighthouses were painted white with red tops, but in the twentieth century they were sandblasted back to their original state. The third lighthouse, also built in 1840 and of a wooden structure, was situated 1½ miles out to sea in the estuary known as Wyre Light, most of which was destroyed by fire in 1948.

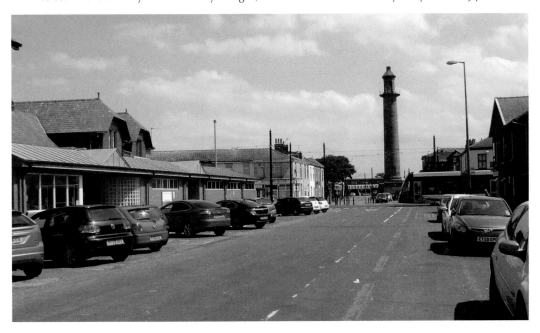

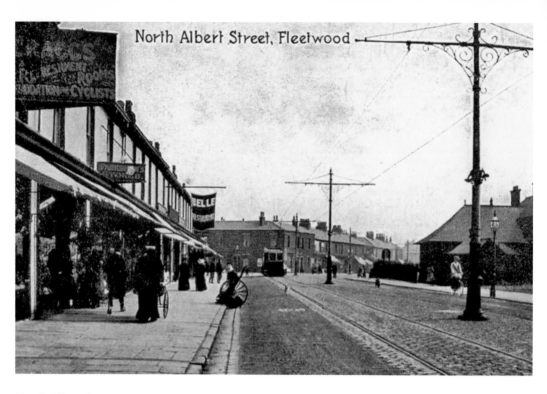

North Albert Street, Fleetwood

North Albert Street

These images of North Albert Street show double tram lines and ornate cast-iron stanchions holding the electric wires, supplying the trams with their power source.

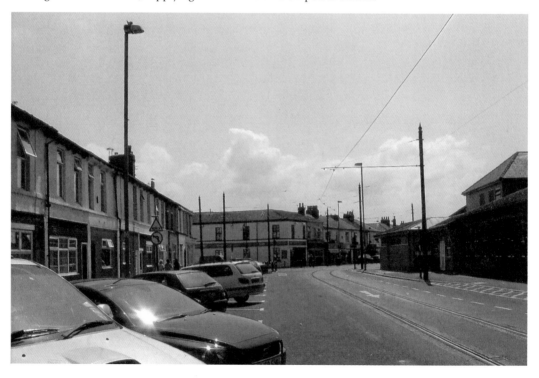

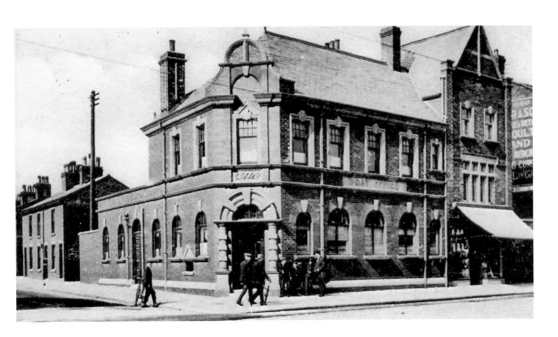

Post Office

The main post office in Fleetwood has been situated in various places in the town over the years. The first one was in Dock Street and the postmaster was Frederick Kemp (it's funny how his name keeps cropping up). The post office in the postcard was built in 1902 on the corner of Victoria Street and North Albert Street, and had a sorting office at the back. As can be seen from the photograph, this fine building has suffered the same fate as the others – closure and possible demolition. The present-day library is opposite, on the other side of North Albert Street.

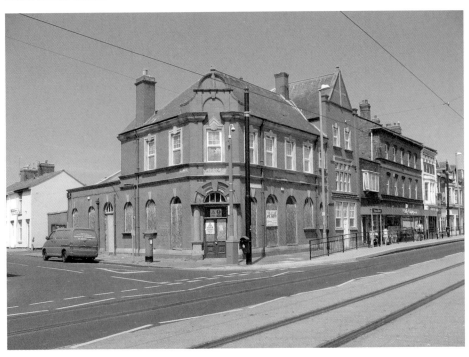

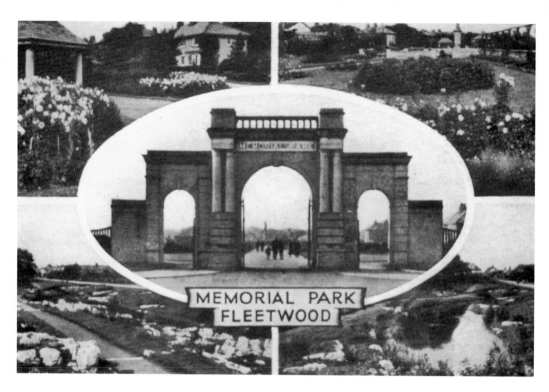

Memorial Park (Once Known as Warrenhurst Park) I

Warrenhurst Park was opened in 1902 and situated at the end of Warrenhurst Road. It was a welcomed green area in the middle of Fleetwood and its only town park.

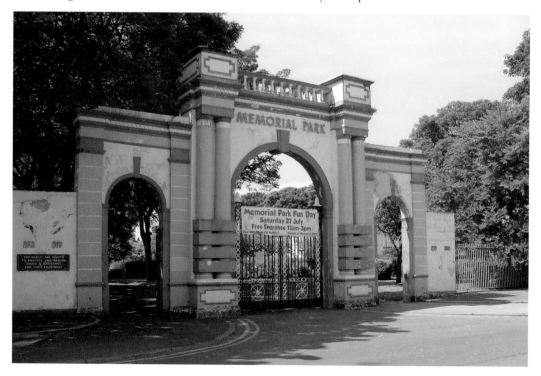

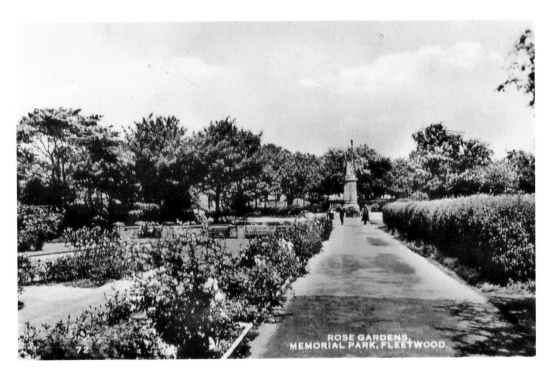

ROSE GARDENS, MEMORIAL PARK, FLEETWOOD.

Memorial Park (Once Known as Warrenhurst Park) II

Warrenhurst Park's name was changed after the First World War to the Memorial Park in 1925, in memory of the Fleetwood men who had fallen in the war. The statue was added later, and trees were planted by children who had lost fathers and relatives in the war. The memorial services, which had taken place at St Peter's church between 1918 and 1927, were moved to Memorial Park when it opened in 1927.

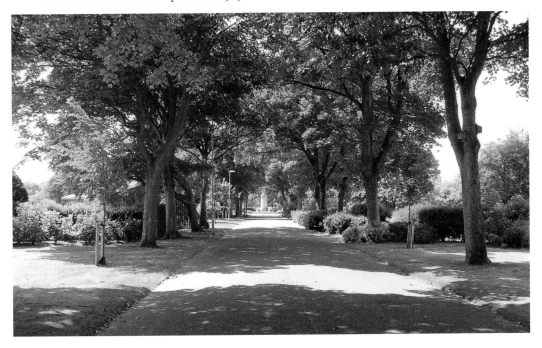

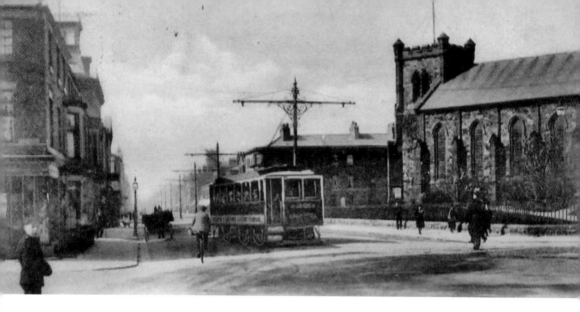

St Peter's Church I

The parish church, St Peter's, designed by Decimus Burton and built in 1840 on land given by Sir Peter Hesketh Fleetwood, who laid the foundation stone, was consecrated in 1841. The stone cross visible in the church grounds (between the black cable-carrying stanchion and the stand holding the flower baskets) was dedicated to the Fleetwood men who lost their lives in the First World War, and services were held here between 1918 and 1927 until the Memorial Park opened in 1927.

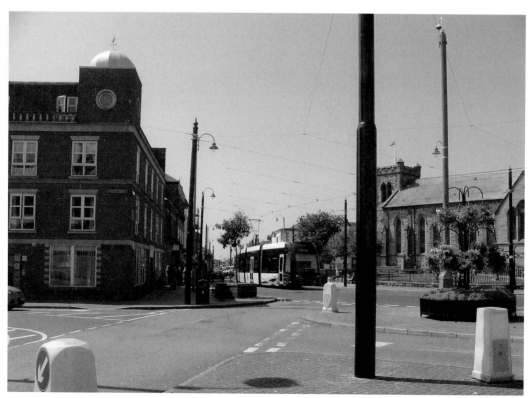

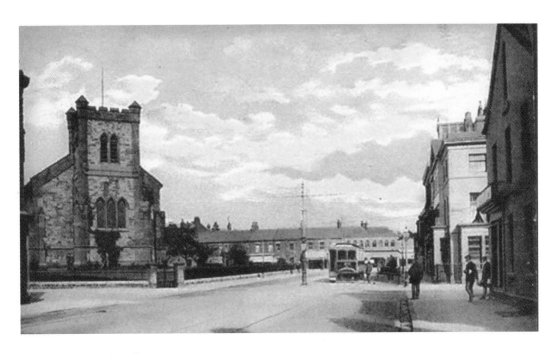

St Peter's Church II

St Peter's originally had a steeple, but it was removed in 1904 when it became unsafe and too costly to repair. The east end of the church was enlarged in 1883 when a chancel, a transept chapel and an organ chamber were added. The church had enough space for 400 worshipers, and 200 more could be accommodated in the galleries on the north and south sides. The galleries were removed in 1960. Prior to 1841, burials took place at Thornton parish church not far away down country lanes.

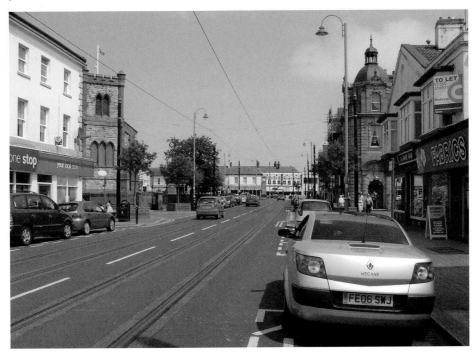

Thornton

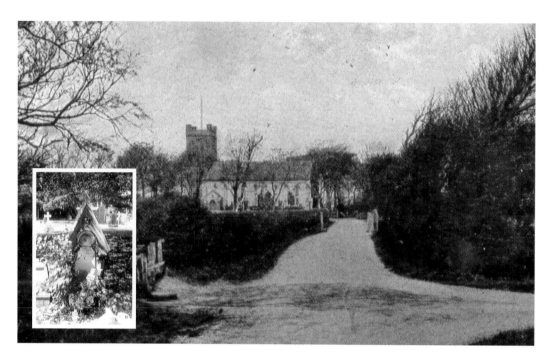

St John the Evangelist Church

This church was built down Parr's Lane (now Meadows Lane) among the trees in the centre of a scattered rural village in 1836 and, as it was the only church in the area before 1840, people were brought from the new nearby town of Fleetwood for burial. The tower and parish rooms were added in 1963. The style on the left was on a footpath to Cleveleys. The inset shows a child's grave headstone in the old graveyard. The sad story that has been told to children over the years as a warning is one of a little girl who choked to death on the marble embedded in the circle at the top of the headstone. Three young children were buried in the grave in 1841.

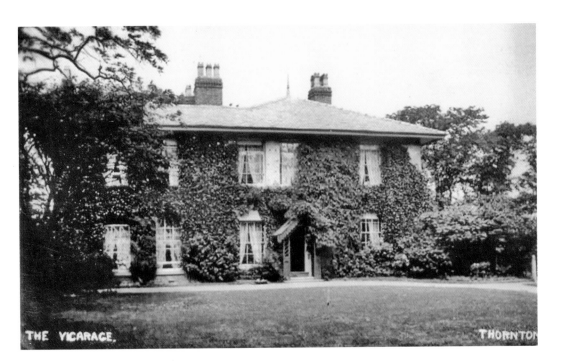

THE VICARAGE. THORNTON

The Vicarage

The vicarage was built at the same time as the church but is now privately owned, with a new smaller one having been built slightly nearer to the church. I would like to thank Graham and Susan Lindsay for allowing me to photograph their tastefully renovated home.

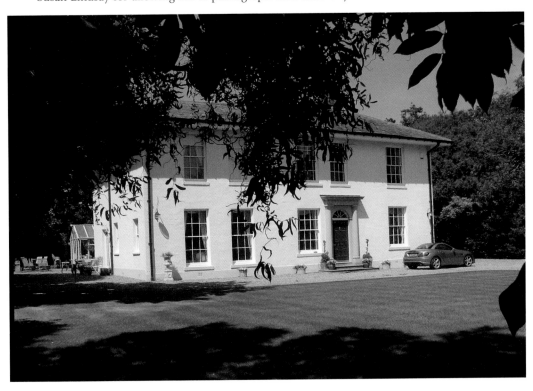

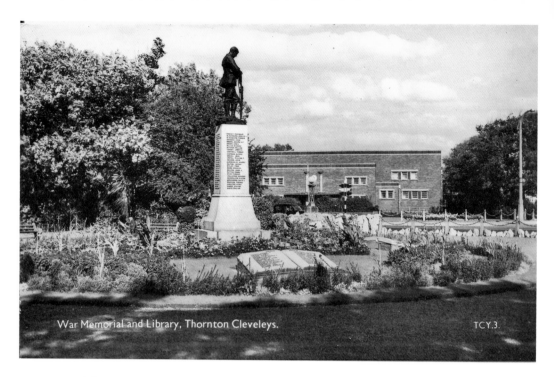

War Memorial and Library, Thornton Cleveleys.　　　　　　　　　　TCY.3.

War Memorial

The original 1919 War Memorial in memory of those killed in the First World War was placed temporarily in Woodlands Avenue, but was rebuilt in 1923 and unveiled on the fifth anniversary of the end of the war at Four Lane Ends, on the junction of Victoria Road East and Fleetwood Road South. The area is now in memory of the tragic loss of lives in both World Wars.

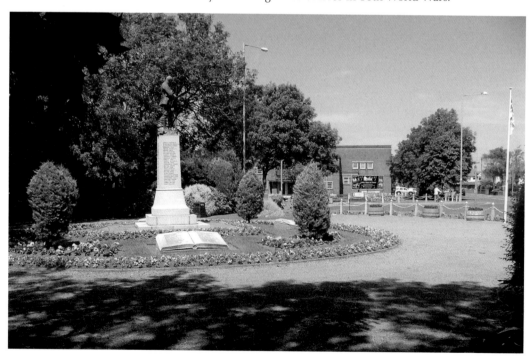

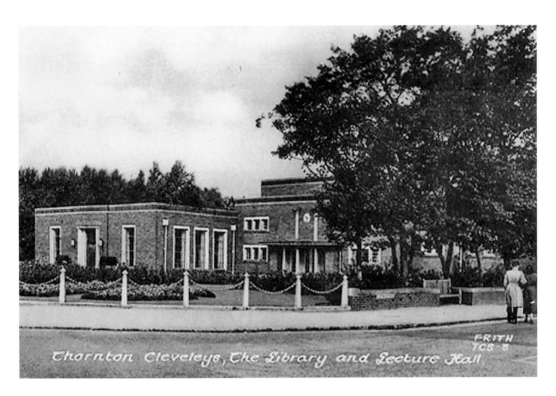

Library and Lecture Hall
On the opposite corner of Four Lane Ends, on the junction of Victoria Road East and Fleetwood Road North, stands the library and lecture hall. Opened by Sir Peter Meadon in 1983, the complex now also houses the Thornton Little Theatre.

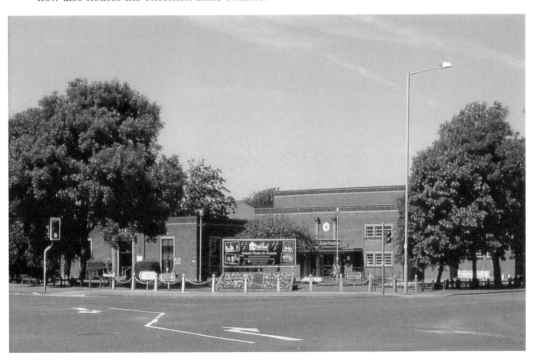

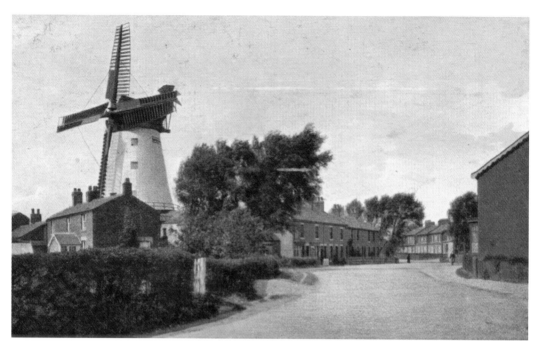

Marsh Mill I

Marsh Mill, looking north, was built in 1794 by Ralph Slater, who also built the mills at Pilling and Clifton. It remained a working mill until 1922, finally being used to grind meal for farm animals. It was restored to full working order in 1990 and is the best preserved mill in the North West. Near the side of the mill was T. Kirkham's blacksmith's shop and in the mill yard was Jack Beckell's wheelwright's shop.

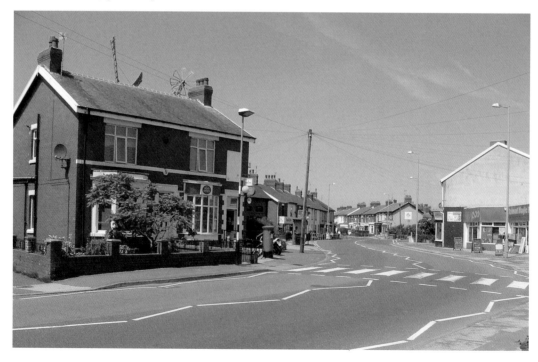

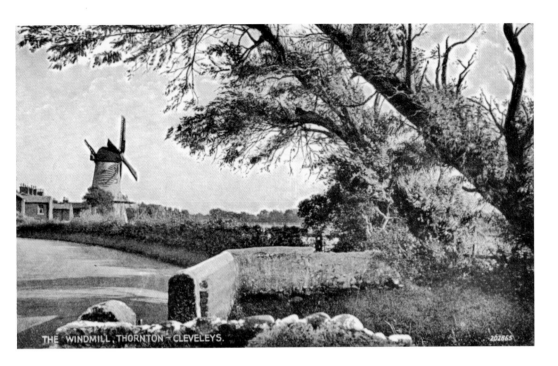

THE WINDMILL, THORNTON - CLEVELEYS.

Marsh Mill II

When built, Marsh Mill was one of the tallest in the country at around 70 feet high, and consisted of five stories, plus the canopy, with four 35-foot wooden sails. After it stopped grinding meal, it was used as a café between 1928 and 1935. About a third of the way up on the outside, a wooden staging ran round the outside of the mill. In 1930, two prospective buyers, Mrs Mary Jane Bailey and Miss Alice Baldwin, went out on this staging to inspect the mill when it collapsed, sending to them to their deaths on the ground below.

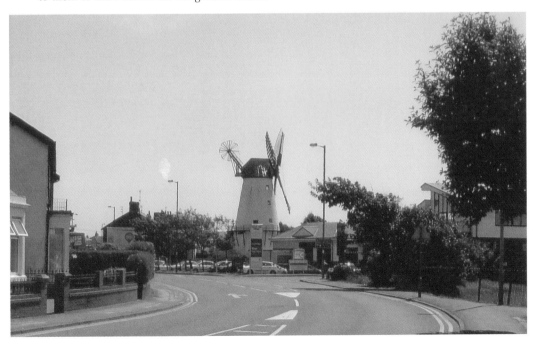

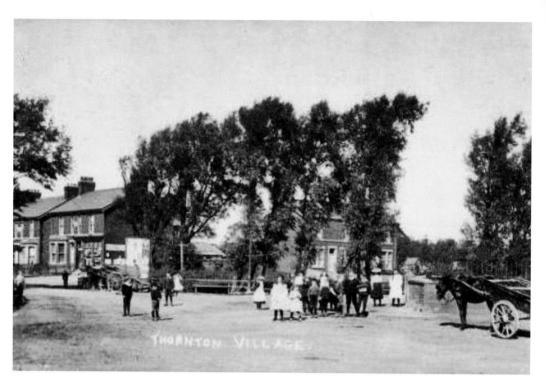

Woodlands Avenue

This calm scene was on the corner of Fleetwood Road North and Mill Lane, and is now known as Woodlands Avenue, not far from the mill.

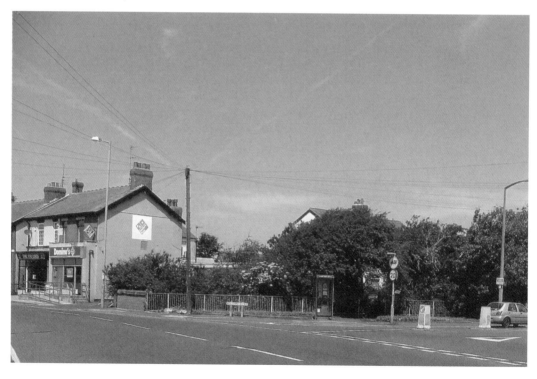

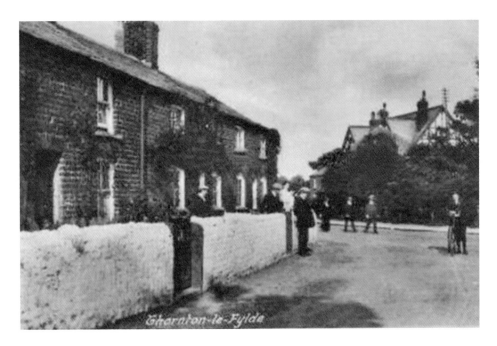

Thornton-Le-Fylde

Pictured here are old cottages on the corner of Church Road and Fleetwood Road North, in 'Thornton-Le-Fylde', near the Gardeners Arms public house which is not far from the mill.

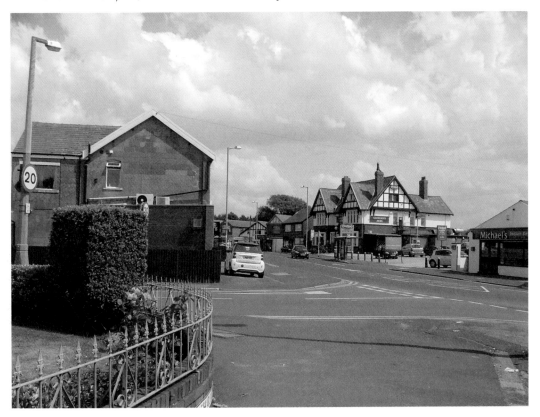

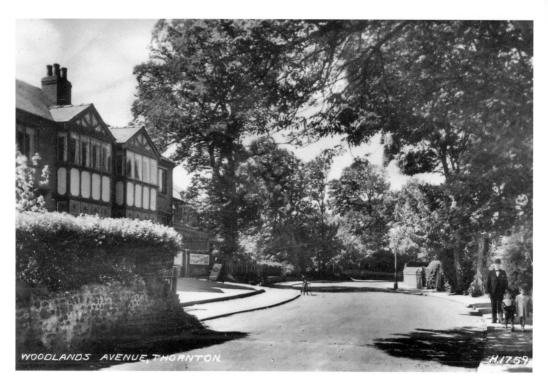

WOODLANDS AVENUE, THORNTON. H.1759

Woodlands Avenue I

On a short stroll along Woodlands Avenue, which mainly follows the course of a wide brook on the left known as Royles Brooke to its junction with Trunnah Road and Lawsons Road, we first pass the houses on the left. These were demolished to make way for modern housing.

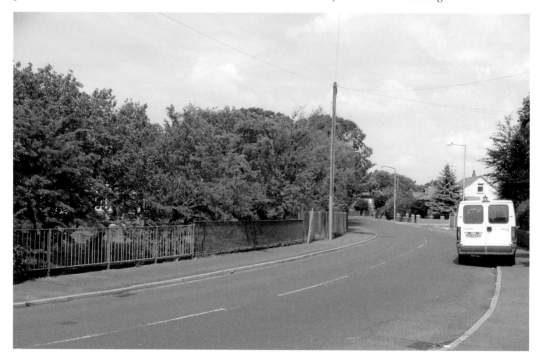

46

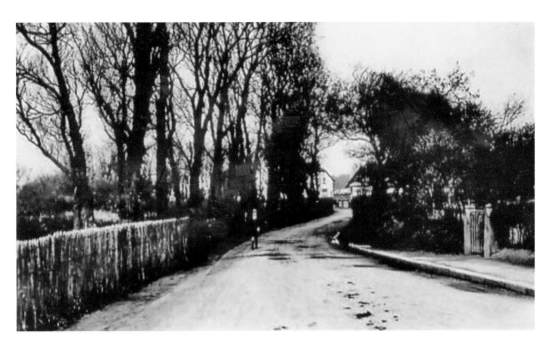

Woodlands Avenue II

Trees line Woodlands Avenue and Royles Brooke on the left. In the distance, the road sweeps round to its junction with Trunnah and Lawsons Roads.

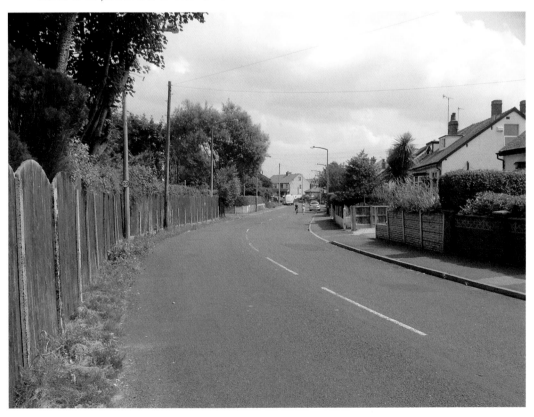

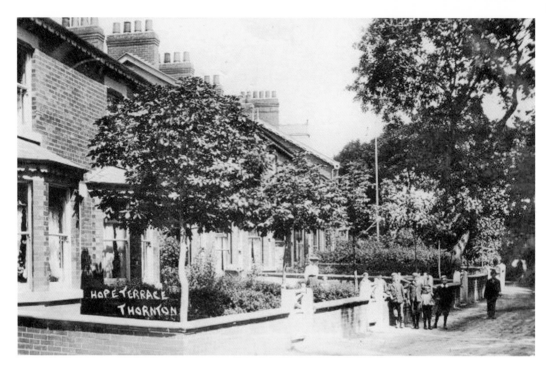

Mill Lane

At the far end of Mill Lane, now known as Woodlands Avenue, terraced cottages stand, which are known as Hope Terrace. They are attached to a slightly larger building called Hope Villa.

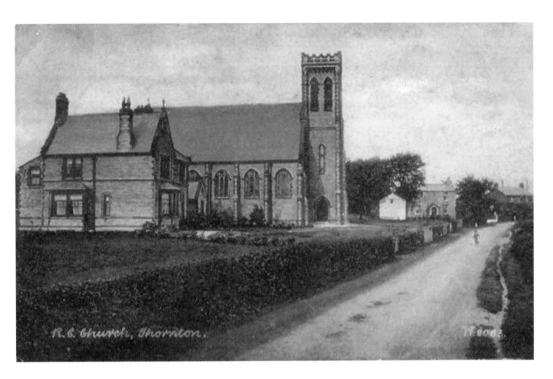

Sacred Heart Roman Catholic Church

Sacred Heart Roman Catholic church, situated on Heys Street, Thornton, was opened in 1899 and after the First World War a stained-glass window was installed as a memorial. There is a school next to the church providing some open spaces, but the rest of the area, which is in close proximity to the now defunct ICI works called Burn Naze, is heavily populated.

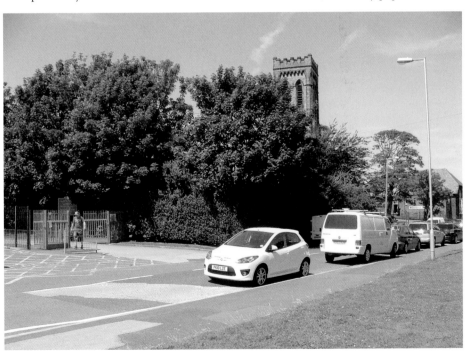

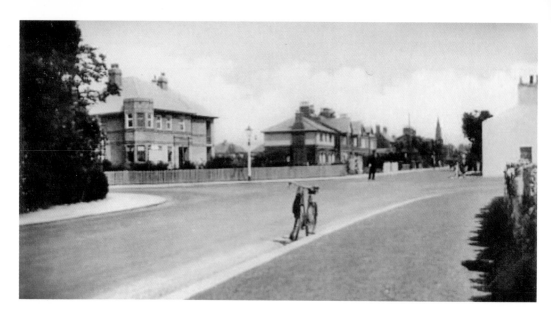

Four Lane Ends

Four Lane Ends looking down old Ramper Road (Victoria Road East), past Wignall church, towards Thornton railway station in the distance. The white building on the right was Swarbricks Farm and later became a branch of Natwest Bank. The building on the left with the ornate corner is the Rushlands Hotel.

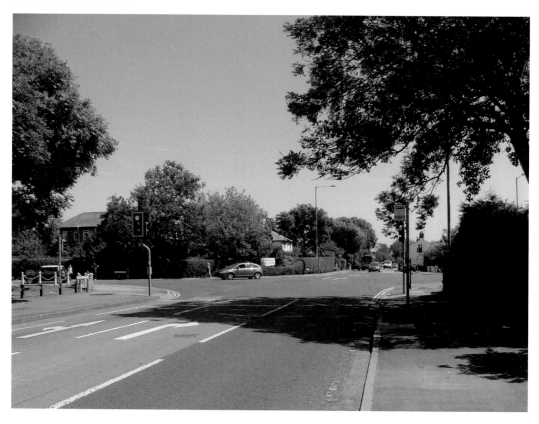

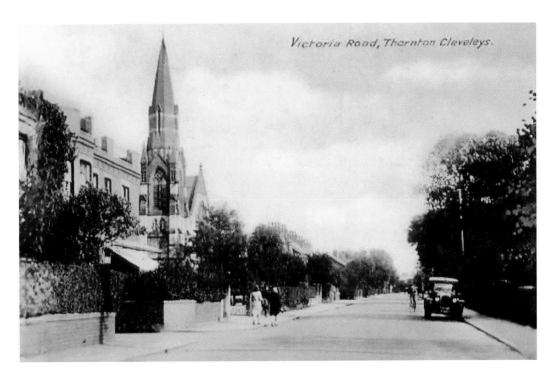

Victoria Road, Thornton Cleveleys.

Wignall Memorial Wesleyan Methodists Church
The church on Victoria Road East was founded in 1812. The first church building was a plain barn-like structure, whitewashed inside and out, and used for eighty years. In 1892 another was built, which became a Sunday school when the present church was built in 1905. The building on the left with the awning used to be a cobbler and clog maker's shop.

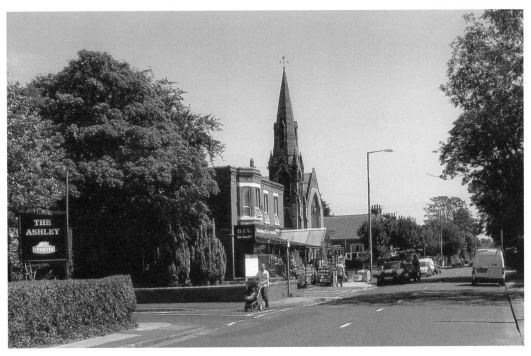

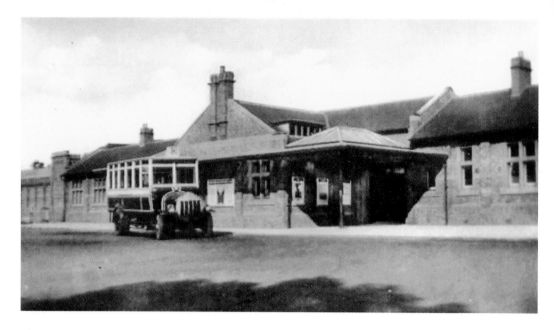

Thornton Station

The railway station entrance. The station has had a few names over the years. When it opened in 1865 it was originally called Cleveleys, even though it was in the centre of Thornton on the Preston to Fleetwood line and was south of the present day level crossing over Victoria Road East/Station Roads. It was renamed Thornton for Cleveleys in 1905. This station was closed in 1927 when a new station was built to the north of the level crossing. Its name was altered again to Thornton Cleveleys in 1953.

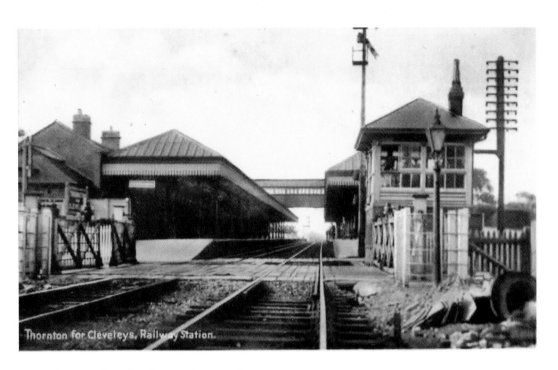
Thornton for Cleveleys, Railway Station.

Thornton for Cleveleys Railway Station

After the nationalisation of the railway system in the 1950s and '60s, and Dr Beeching's order to close the passenger line to Fleetwood in 1966, Thornton Cleveleys' passenger trade soon followed suit, closing in 1970. Following years of neglect, in 2007 the Poulton and Wyre Railway Society obtained a lease allowing them access to a section of the line between Station Road crossing and Hillylaid Road crossing, with the purpose of clearing all the weeds and rubbish and restoring what was left of the station.

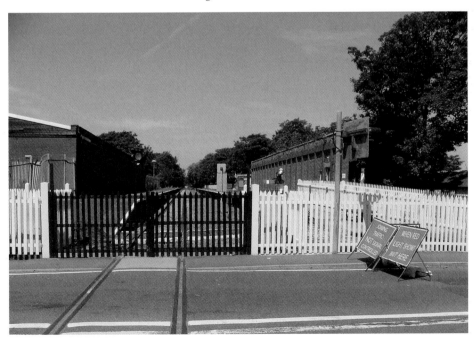

Cleveleys

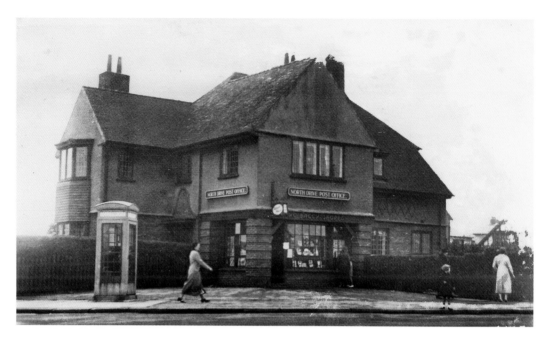

Ye Baccy Shoppe
As we head out of Thornton, down Victoria Road East, towards Cleveleys, we pass Ye Baccy Shoppe (which at one time was also a post office) on the corner of Victoria Road West and North Drive, which is now closed.

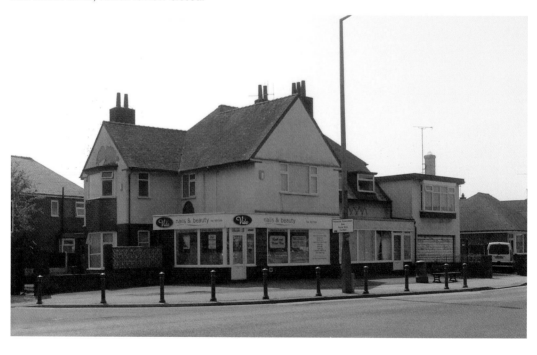

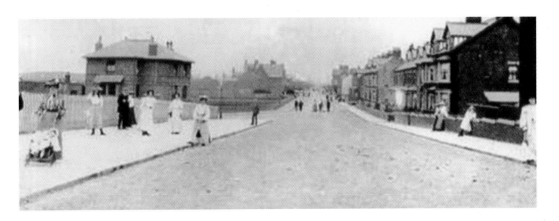

Ramper Road

View down Ramper Road (Victoria Road West), from the seafront towards the centre of town. The name Ramper derives from the ramparts and embankments built to enclose the local marshes; they also formed part of an early sea defence system trying to delay the erosion of the beach and cliffs, which was taking place all along the Fylde Coast. The inset image is from the same period, but taken from lower down the road outside Sherbrooke House.

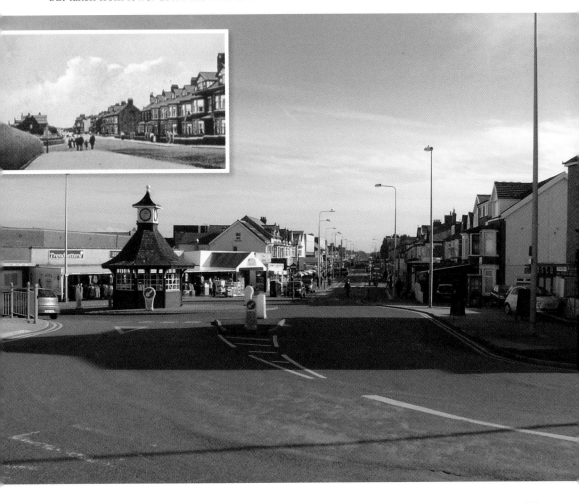

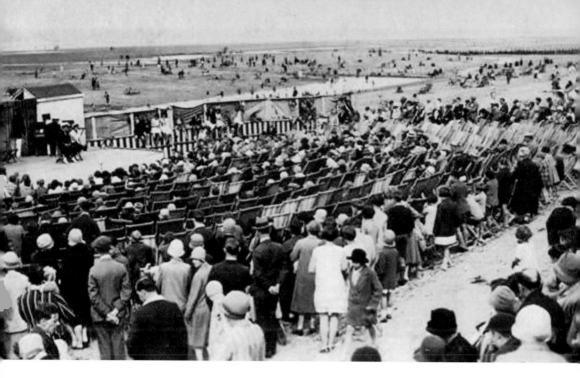

Cleveleys Seafront

Entertainment started early on Cleveleys seafront. The postcard above shows the Pierrots performing to quite a large audience – I wonder if the ones seated on the deckchairs paid and those standing didn't? These performers were probably the forerunners of those that entertained the crowds when the Arena was constructed. Note also the number of visitors on the beach engrossed in making their own entertainment.

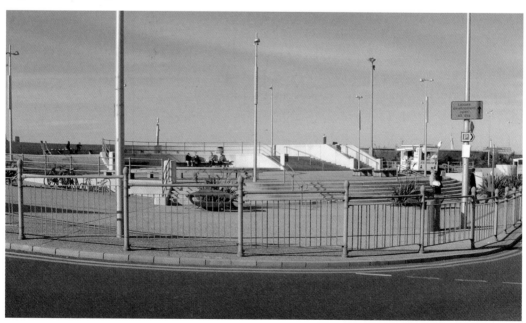

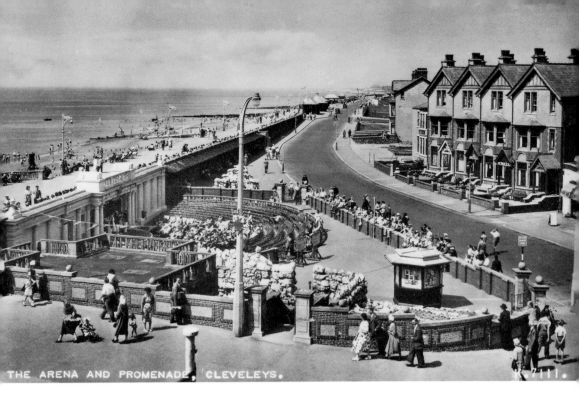

THE ARENA AND PROMENADE, CLEVELEYS.

The Arena and Promenade

The Arena (looking north), the only open-air theatre on the North West coast producing 'Follie Shows' (a sparkling Pierrot Show), was one of the first places of entertainment in blossoming Cleveleys. The first semicircular open-air seating area was established before the promenade was built at the end of Victoria Road West.

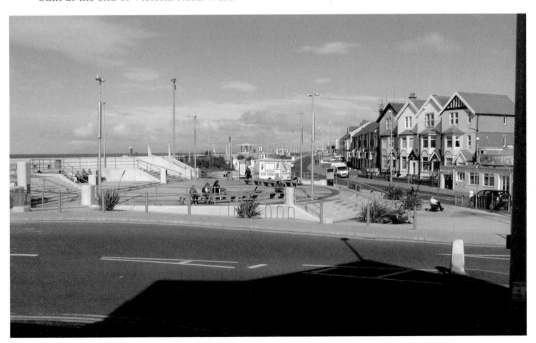

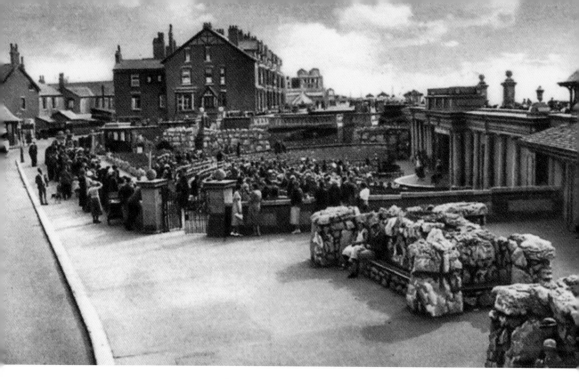

The Arena I

The Arena (looking south), shown here when the promenade sea defences were built and the Arena refurbished, with part of the stage ending up under the promenade. During summertime at the Arena, a non-stop show of singers, variety acts and dancing girls performed what was known as the Follies.

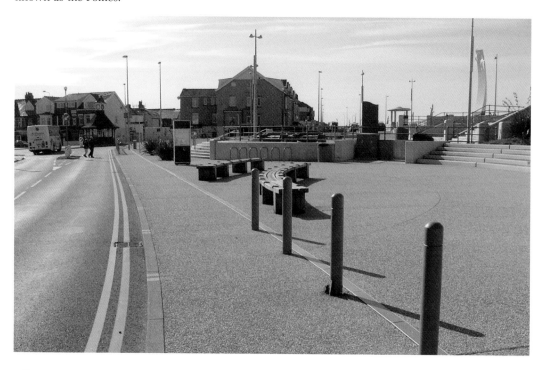

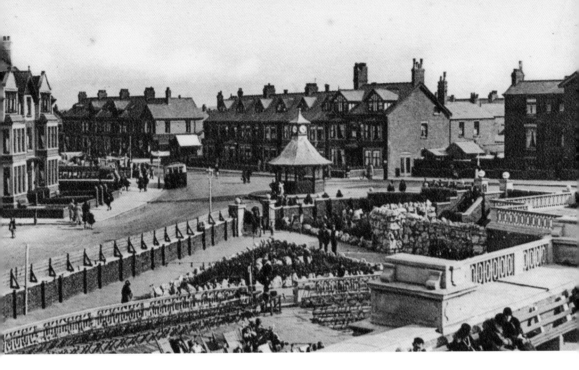

The Arena II

The Arena at the junction of Garfield Road, now north promenade, Promenade Terrace, now south promenade, Ramper Road, now Victoria Road West, and Rough Lea Road.

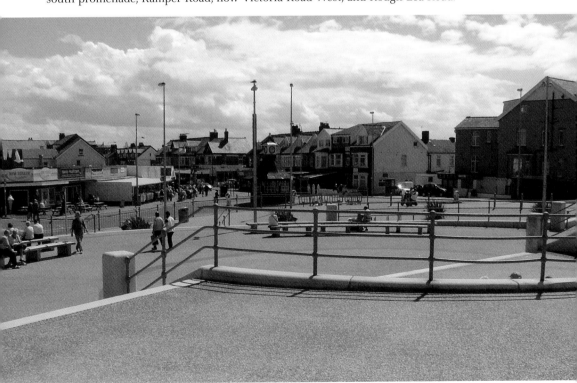

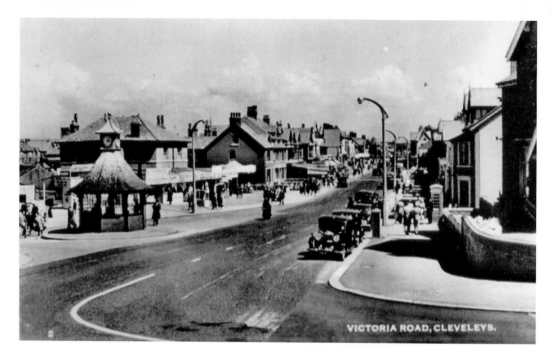

Victoria Road West

A later and more built-up view of Ramper Road, renamed Victoria Road West, taken from the promenade at the time of Queen Victoria's Jubilee. Previously, the only way to reach the new resort was by foot or coach and horses; even if you arrived by train, the station was about two miles away at Thornton, so you still needed transport from there. As shown in the postcard, the motor car had since arrived, making it far easier to reach.

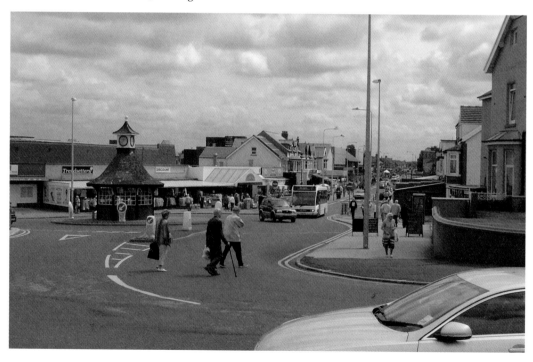

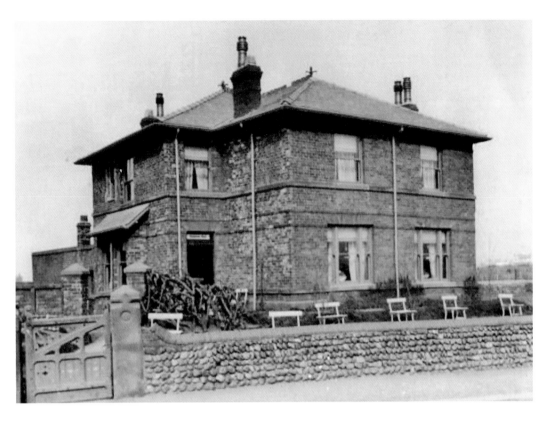

Victoria Road West Junction

Around the junction of Victoria Road West and the promenade there were one or two buildings worthy of a mention. In the previous postcard (*see p. 60*), the first house on the left behind the gazebo is the one depicted here. It was called Sherbrooke House, and consisted of five apartments and two sitting rooms.

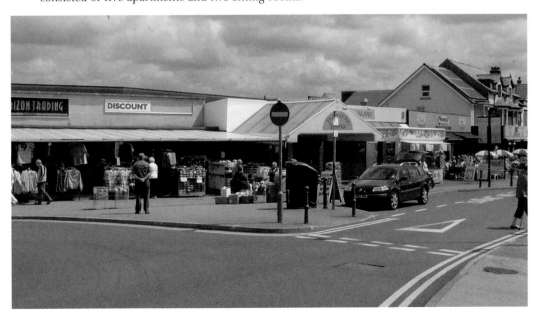

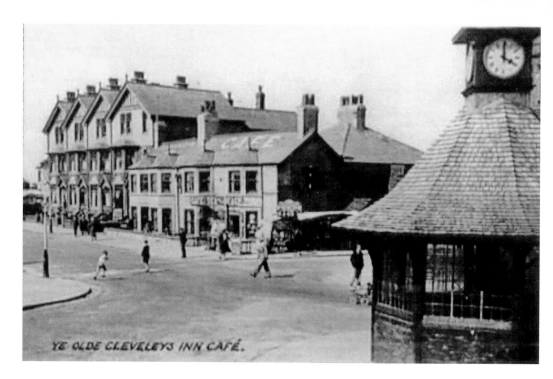

Ye Olde Cleveleys Inn Café

Another building whose history is unfortunately fast fading is Ye Olde Cleveleys Inn Café. Long since demolished, it was originally an eighteenth-century coaching house. It became Ruskins Photo Studio and later the site was taken over by Masons Amusements, but is now occupied by the Olympia. This picture shows it attached to four apex houses, which are still standing today.

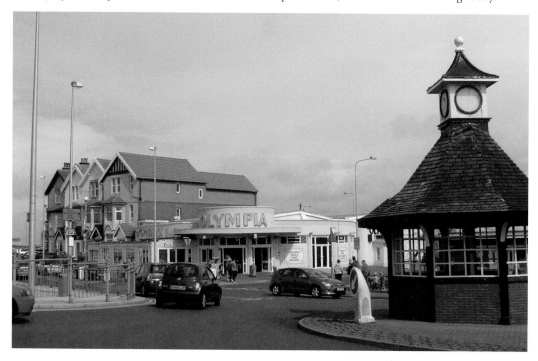

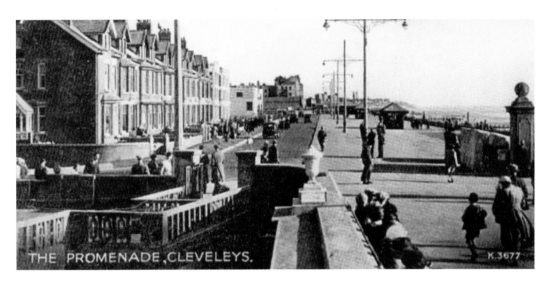

THE PROMENADE, CLEVELEYS.

K.3677

Cleveleys Promenade I

This early view looks south towards Bispham and beyond, with the natural sea defences of cobbles and shingle still in existence. The whole area prone to flooding in stormy weather. An attempt to stop this with the construction of a new promenade took place, as shown in the postcard above. The houses on the left are still in existence, but the Hydro has succumbed to the bulldozer. The inset shows the Cleveleys Hydro standing alone and magnificent in the distance.

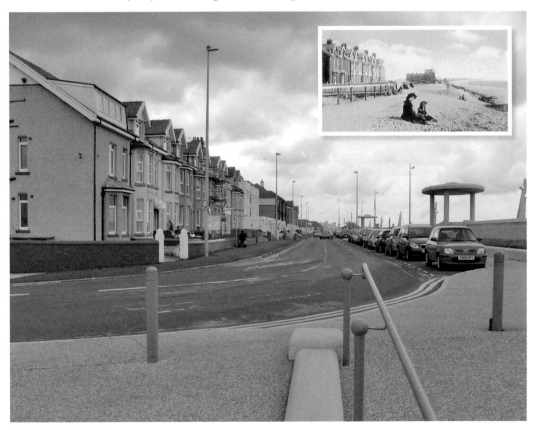

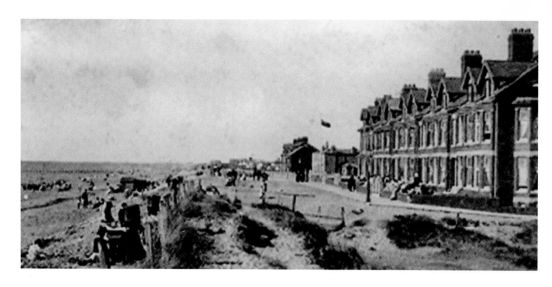

Cleveleys Promenade II

What a lovely natural promenade looking north towards Rossall. It is such a pity the unpredictable sea had the nasty reputation of eating up the land, by eroding the Fylde Coast during the frequent storms, much to the local landowners' annoyance, who hated seeing their properties being washed away by the sea. The original prom took ten years to build (1927–37) and cost £30,000. The insets show the various promenades that have been built over the years. The houses on the right are now mainly converted into holiday flats.

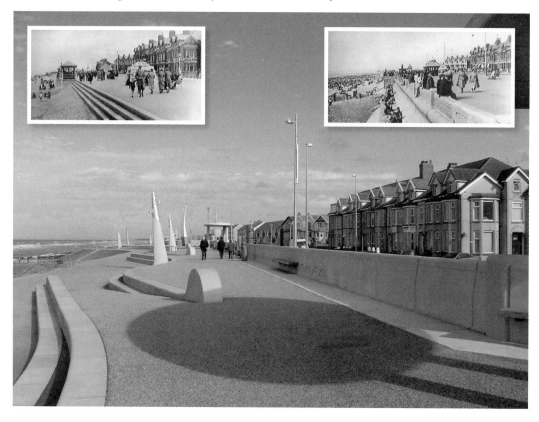

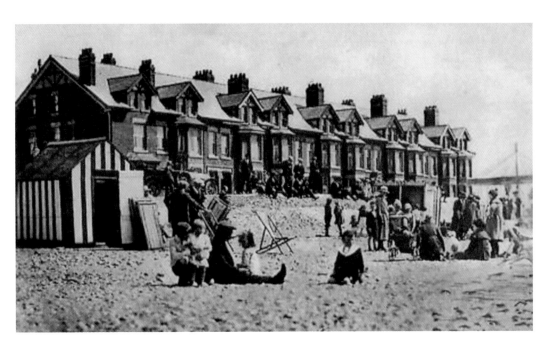

Cleveleys Terrace

Situated on the central promenade, Cleveleys Terrace is pictured here, in the days when all the men and boys seemed to wear flat caps (called ratters in Cheshire). There must be lovely ever-changing sea views from here, especially at sunset, for which the area is well known. The hotel on the far end of the terrace and round the corner into Coronation Street was the Brianholme, and on the other side of Coronation Street before the Queens Theatre stood the Hungerford Private Hotel.

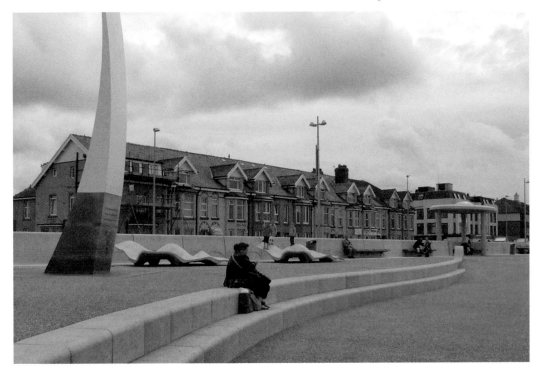

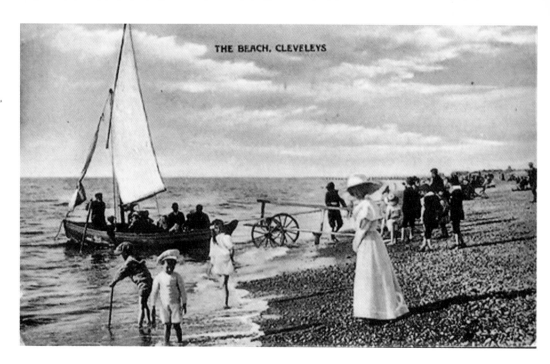

THE BEACH, CLEVELEYS

The Beach

Here we have what we like to remember – a nice and warm tranquil scene at Cleveleys seaside. The pleasure boat had just been loaded with passengers who used the gangplank, supported on what looked like two wooden cartwheels to get aboard, and was ready to set sail along the coast. The lady in the long white dress seems to be looking after three children, or is she? I have seen a nearly identical postcard minus the boat and boarding apparatus and only two of the children.

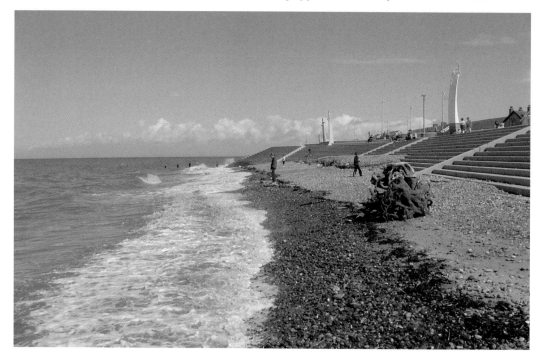

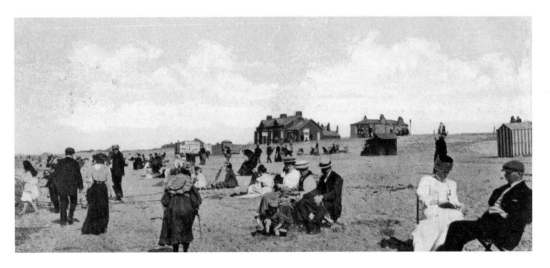

The Beach
The postcard above dates from 1909, showing a busy scene on the beach, just north of Victoria Road West, before the sea defences were started. The inset shows the same area fifty years later, according to the postmarks on the postcards, with deckchairs now available in the area.

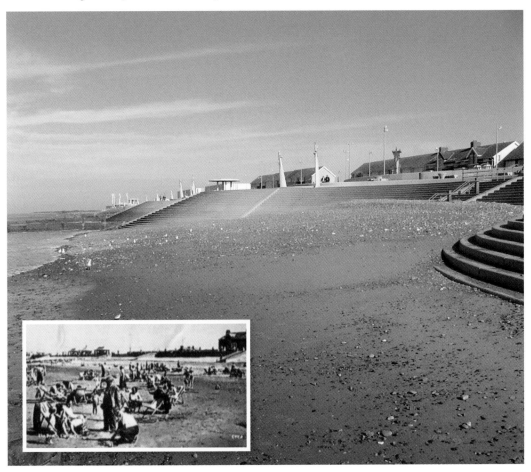

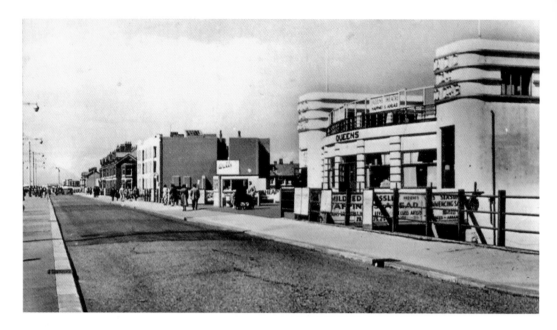

Queens Theatre

Art Deco style Queens Theatre, later the Showboat, for many years put on a show called *Happiness Ahead*, produced and directed by Mildred Crossley. One of her early successful artistes was the all-singing, all-dancing comedian, the youthful Roy Castle, who joined Mildred when he was twelve but could not get a licence to perform until he left school at fourteen years of age when he took a juvenile lead in *Youth on Parade*. Near here there was a bar known as 'Nellies Bar'. If anyone got a bit out of hand the landlady would get them outside and beat them with a broom, telling them they were barred.

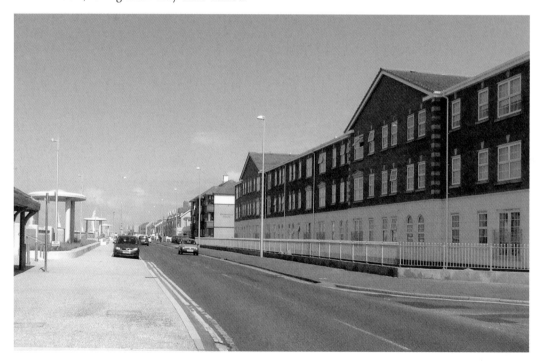

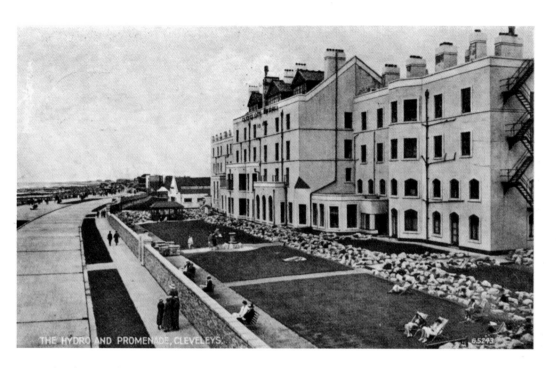

THE HYDRO AND PROMENADE, CLEVELEYS.

Cleveleys Hydro I

Cleveleys Hydro opened as a hotel in 1889. With its front on the promenade, it was built on the site of an old hunting lodge called the 'Eryngo' (the name of the sea holly that used to grow in abundance here), which belonged to Alderman Dr John Cocker, Blackpool's first mayor. A fine range of game including deer, rabbits, hares and pheasants roamed among the sandhills here. With the building of the Hydro, the wilderness area disappeared under tennis courts and an 18-hole golf course.

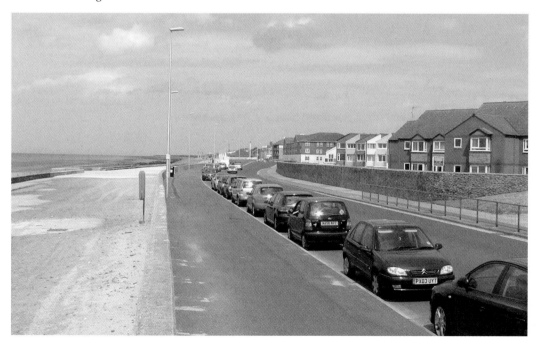

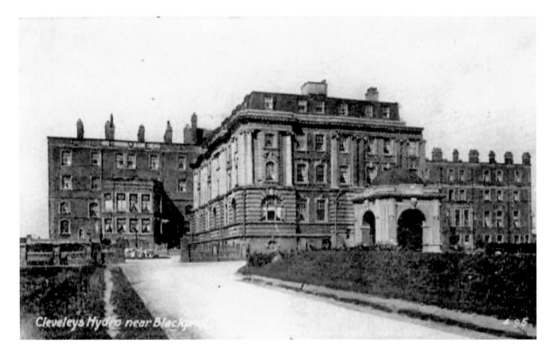

Cleveleys Hydro II

In 1912, Cleveleys Hydro was widely advertised as both a summer and winter destination, comprising of a fully licensed hotel with central heating, a resident orchestra and other entertainment, garage space for eighty cars, an 18-hole golf course, and grass and shale tennis courts. The rear eastern wing was added in 1907 and had forty bedrooms and a variety of remedial baths such as Turkish, Russian, brine and sulphur, gaining a national reputation until it closed in 1939. It was used as a hospital during the Second World War, and had one or two other uses afterwards before being demolished in 1957.

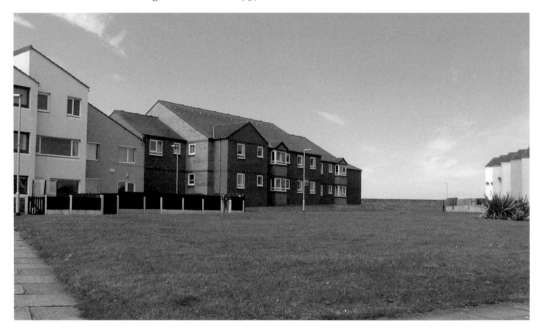

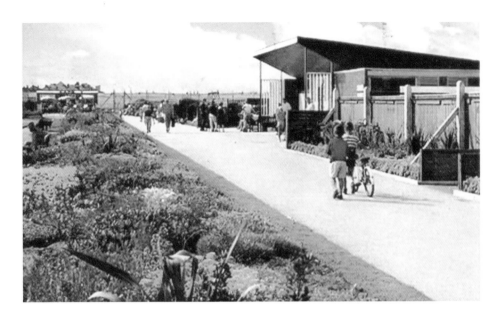

Cleveleys Hydro III
Cleveleys Hydro in the early days could be seen from distant places as it stood alone on the seafront. In the grounds surrounding it, an 18-hole golf course was built, which extended south, taking in most of the Anchorsholme Promenade land. With the demise of the Hydro, the area surrounding it and a large part of the golf course soon disappeared under bricks, mortar and tarmac. Luckily part of it was saved and the area known as Anchorsholme Park was created, providing a miniature 18-hole golf course, two bowling greens, a small 9-hole pitch and put course, a children's play area equipment and a café.

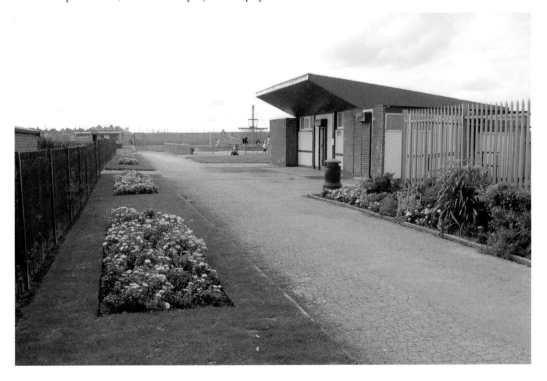

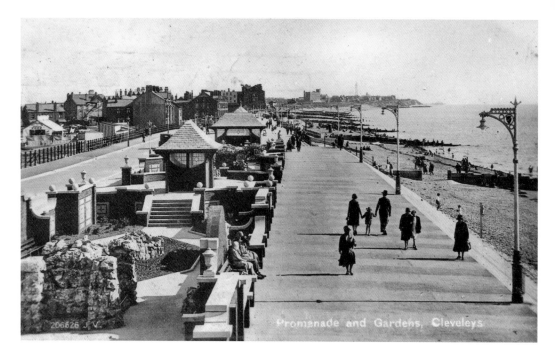

North Promenade Looking South

In the early days, the area between Jubilee Gardens and Victoria Road was occupied by the Pleasure Beach with its dodgems, slot machines, helter-skelter, carousel, daredevil shows and wooden big dipper. The dismantling and transportation of the big dipper (to be re-erected at Battersea Park Fun Fair in time for the Festival of Britain in 1951) and eventual closure of the Pleasure Beach was probably the beginning of the end for Cleveleys and a threat to the other holiday resorts along the Fylde Coast.

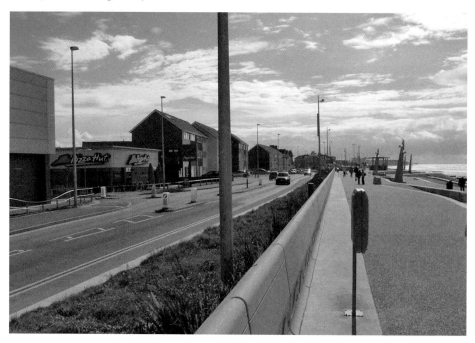

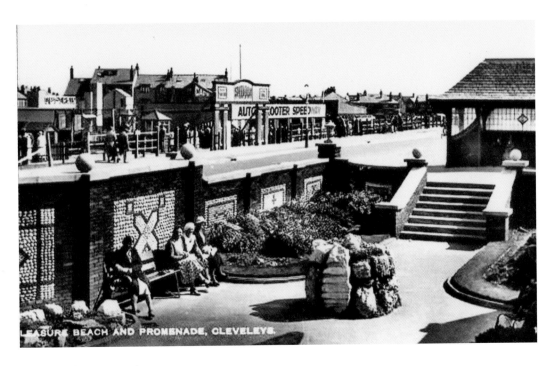

PLEASURE BEACH AND PROMENADE, CLEVELEYS.

North Promenade

A later, more built-up view of the north promenade, showing more of the 'sunken gardens'. The white apex, just visible between the Pizza Hut and the flats, is the same apex that has 'Café' printed on it in the postcard. It is now the Ocean Garden Restaurant, which is attached to the Travellers Rest pub in Beach Road. As can be seen in the photograph, the Pleasure Beach has disappeared under later developments.

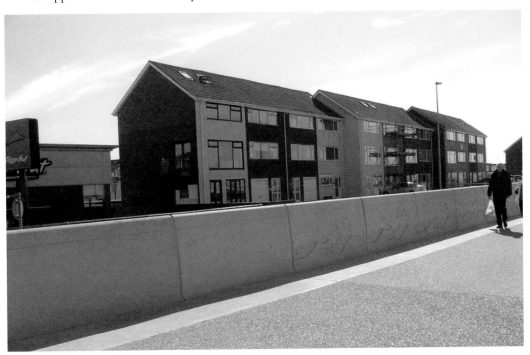

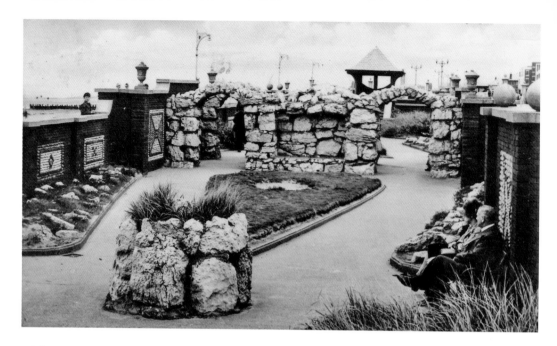

Jubilee Gardens

The Jubilee 'ornate sunken' Gardens, looking north from near Beach Road. The postcard is dated 1948. In this area there used to be an annual art exhibition and sale run by local art organisations; Sheila Helliwell, who at the time of writing still lives in the town, was one of the driving forces behind it. She was the only person at that time, so she told me, who did not work for Blackpool Council, to have her Comic Cats pictures made into part of the illuminations to be displayed in the Manchester Square area for five years.

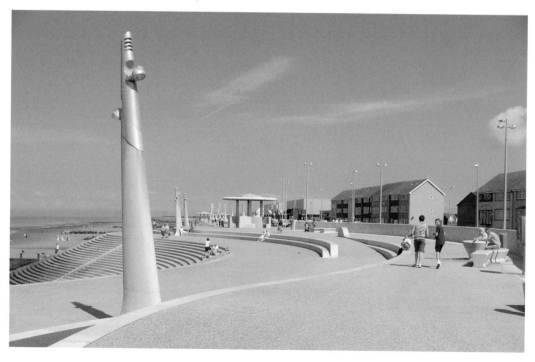

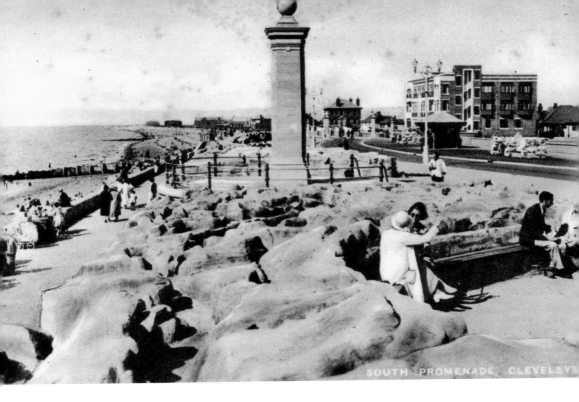

SOUTH PROMENADE, CLEVELEYS

Cleveleys Promenade I

The promenade with Rossall in the distance. On the right is the Royal Hotel (now called the Venue), which is situated on the northern side of the Jubilee Gardens. The police station, which is now closed, is still there a bit further on. The Gardens were a favourite haunt of the youngsters, and a revamp began in 2005. In this area there were also fourteen cream-coloured beach huts, which are long since gone.

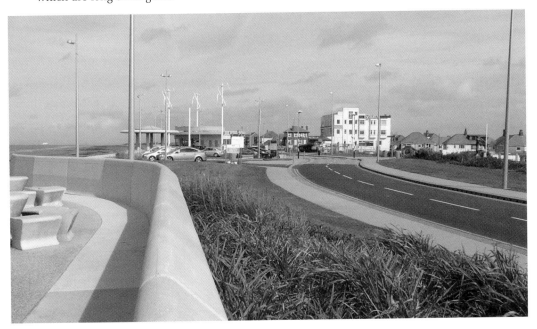

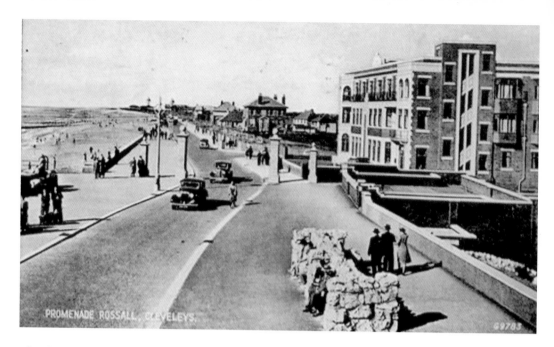

Cleveleys Promenade II

There seems to me to be an optical illusion with this view of the Royal. Depending how you look at it, the white area up the middle, which I assume are the internal stairs, appears to be jutting out like a fire escape. Rumour has it that the Royal was used as a hospital during the war, with the 'Kings' downstairs being used as a morgue. Consequently the area is supposed to be haunted, with strange things happening so much so that staff refused to go down the stairs on their own. There is still evidence in the grass of the rough 'boulder' seat that is being passed by the three people.

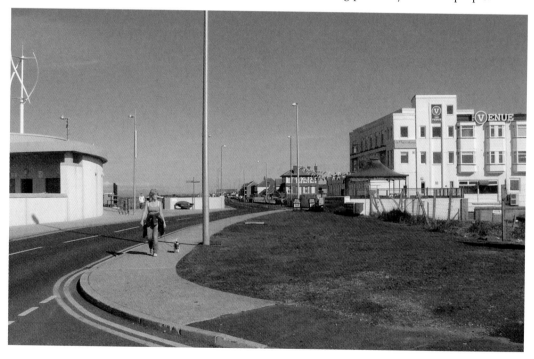

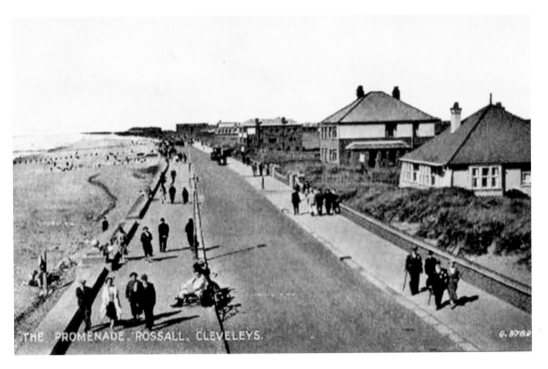

THE PROMENADE. ROSSALL. CLEVELEYS.

Cleveleys Promenade III
North promenade leading to Rossall promenade and Rossall beach with Fleetwood in the far distance, as seen from just past the old police station.

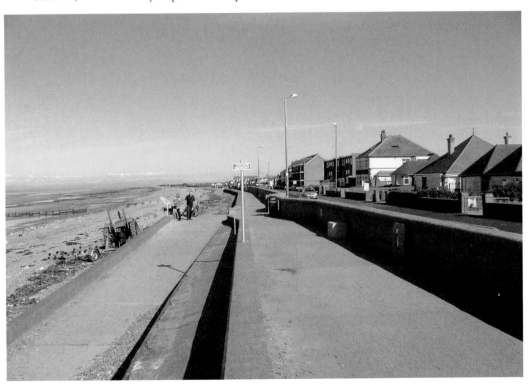

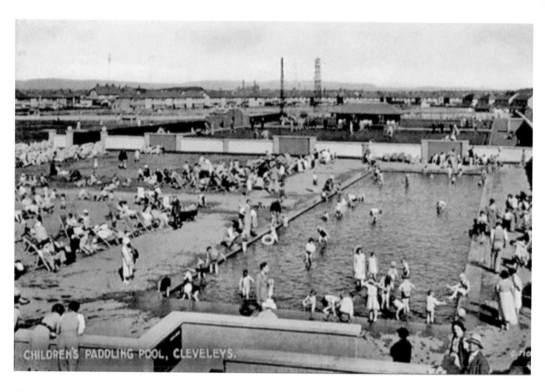

CHILDREN'S PADDLING POOL, CLEVELEYS.

Cleveleys Paddling Pool I
The children's paddling pool on north promenade looking south, with what appears to be bowling greens beyond it. There's not much that can be said about the depressing photograph below.

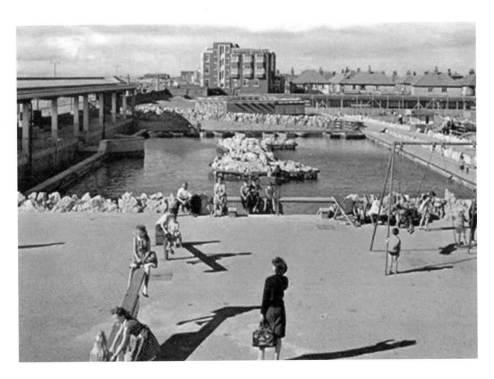

Cleveleys Paddling Pool II
The paddling pool situated on the north promenade near Jubilee Gardens. There were no rubber-type safety mattresses to comply with Health and Safety Rules under these swings and other playground equipment in those days, which have robbed the children of today the chance of getting grazed skin and battle scars to display and talk about later in life.

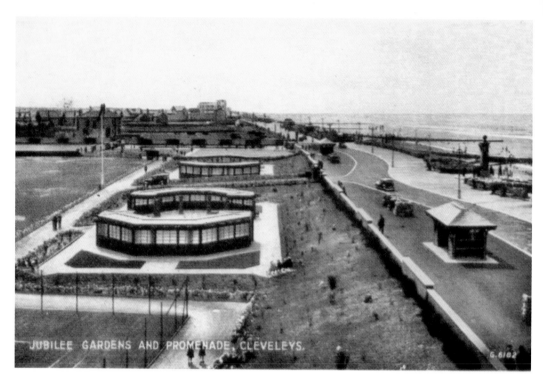

Jubilee Gardens and Promenade

View over the early Jubilee Gardens and promenade from the Royal Hotel. The area has changed over the years, as depicted in the modern photograph below.

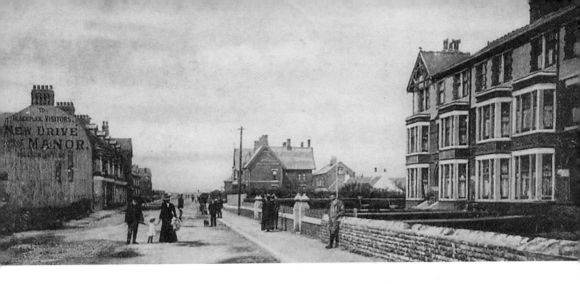

Victoria Road West

Unmade Victoria Road West (formerly Ramper Road) at Cleveleys. The front of the building on the left with the rounded roof can just be seen jutting out where the Regal Hotel now joins it. The inset shows an image taken at a similar period in time but from higher up, nearer the seafront.

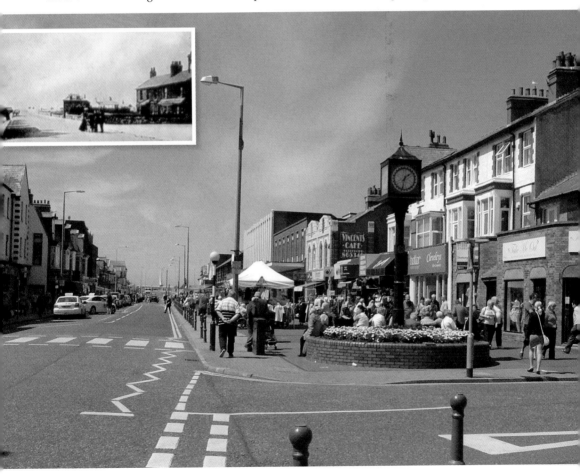

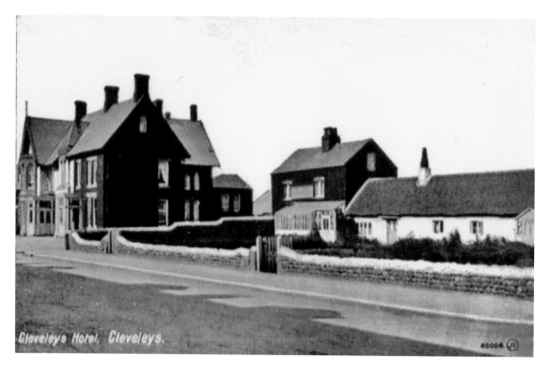

Cleveleys Hotel

Cleveleys Hotel and cottages on Victoria Road West. The building in between with the conservatory was used by Whitby's as a plumber's and decorator's business premises, enclosed by sea-washed cobbled walls that have unfortunately long since gone. The modern picture even shows the shadows on the footpath. The hotel was still being used in the early 1980s.

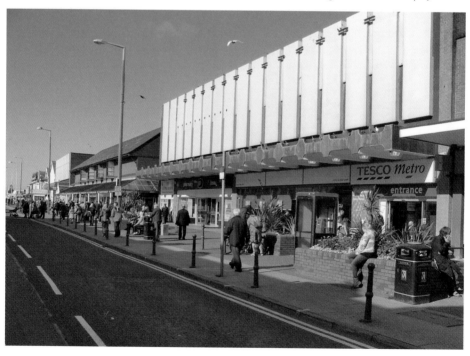

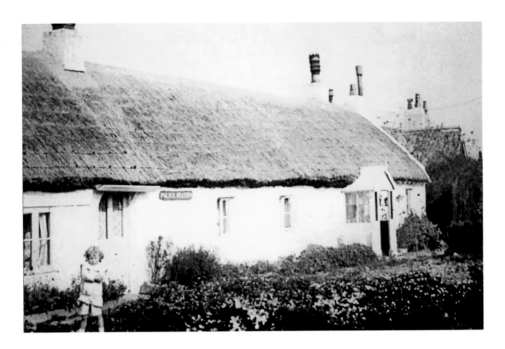

Thatched Cottages, Near the Cleveleys Hotel

The thatched cottage on the right with the porch was called Rose Cottage and I believe at one time it was depicted on a piece of Commemorative china. On the board over the window of the cottage on the left, 'Cleveleys Post Office' was written. It later became the police station, hence the sign to the right of the door. At the end of the cottages, the unique chimney pots and apexes of Major Nutter's bungalow can be seen.

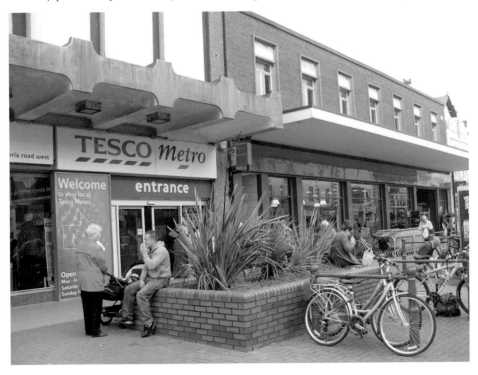

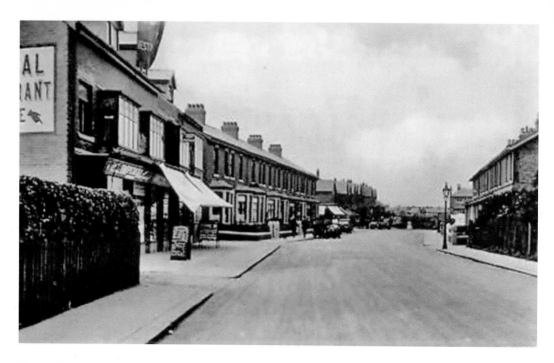

Nutter Road

Nutter Road was named after Major W. Nutter, a local landowner and sportsman who also had a large bungalow nearby. Abbots Garage and Coaches were stationed for many years where the Wilkinson store is now situated.

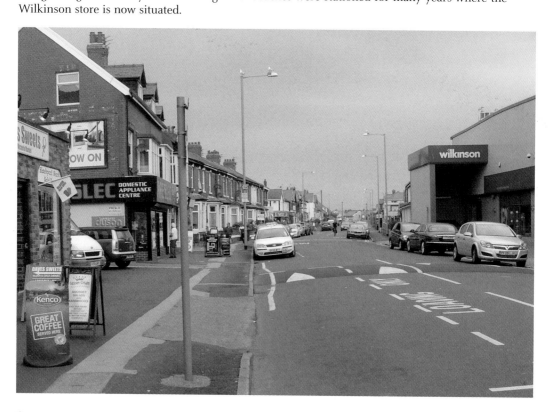

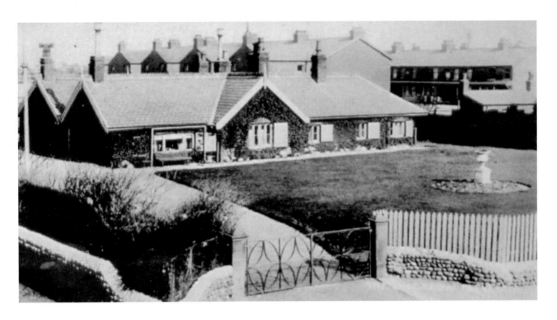

Major Nutter's Bungalow

I would like to thank the management and staff of the Regal Hotel for allowing me to take the photograph from the upstairs window of their restaurant. Nutter Road can be seen in the background. A Miss Stricklands occupied the bungalow for some time after Major Nutter.

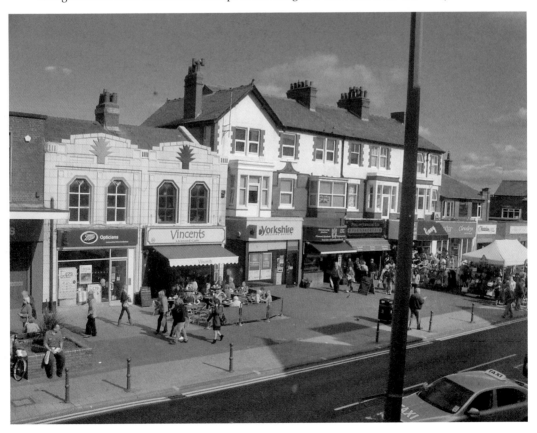

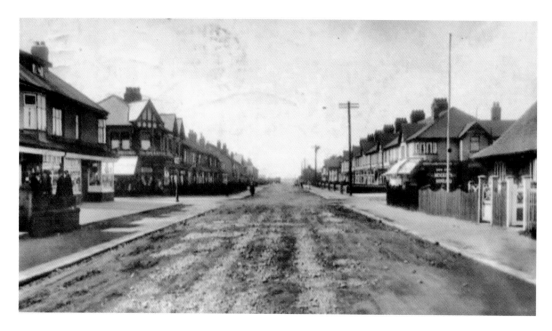

Beach Road
Looking west down Beach Road to the sea from its junction with Rossall Road.

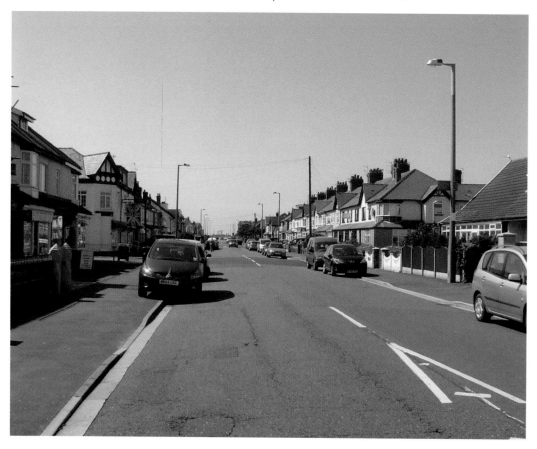

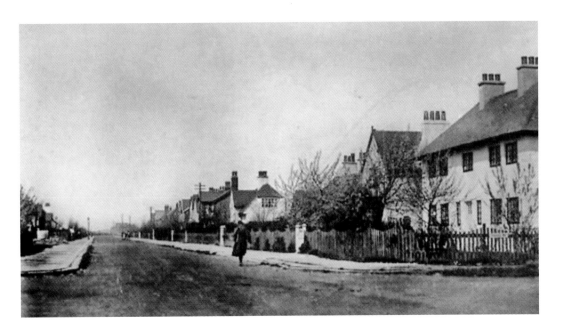

West Drive

West Drive, the entrance to Cleveleys Cottage Exhibition, opened in 1906 and covered an area of land off Cleveleys Avenue. The area was divided into three roads – West Drive was the main and longest one, and Stockdove Way and Whiteside Way were on either side of it. The exhibition enabled the building of various styles of houses for sale to the public; the Dutch Cottage was one of the main show homes (*see p. 89*).

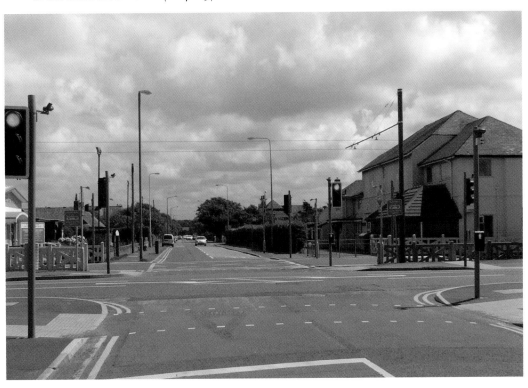

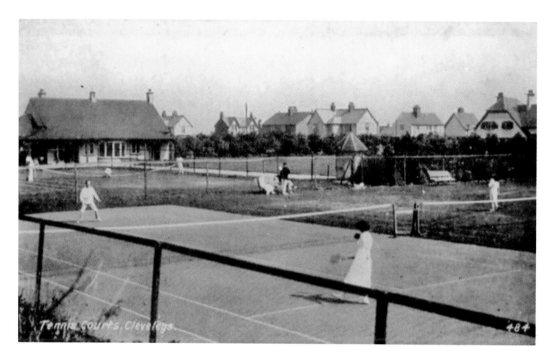

Tennis Courts

According to the *Healthy Cleveleys Magazine,* issued in 1913, the well-appointed clubhouse and grounds of the Cleveleys Bowling and Tennis Club was situated at the West Drive entrance to Cleveleys Park. There are four grass tennis courts, one asphalt tennis court and a fine bowling green, but arrangements are being made for the conversion of one of the tennis courts into a croquet lawn. The front of the building is now the Masonic Hall with the bowling clubhouse at the back.

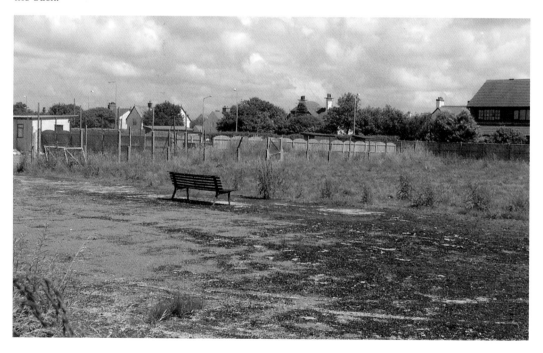

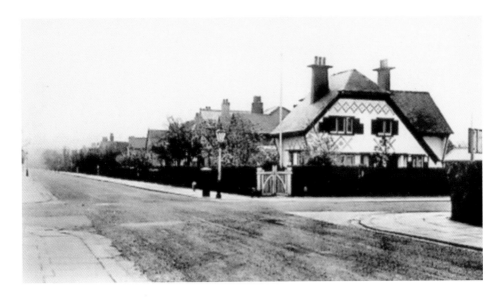

Dutch Cottage

Situated on the corner of West Drive and Cleveleys Avenue is what is called the Dutch Cottage. It is now difficult to see with all the trees and hedges, but when it was first built as one of the show houses for the Cottage Exhibition it was very prominent. The entrace gate has now been replaced with a replica, since the original was destroyed in a road traffic accident at the time of writing.

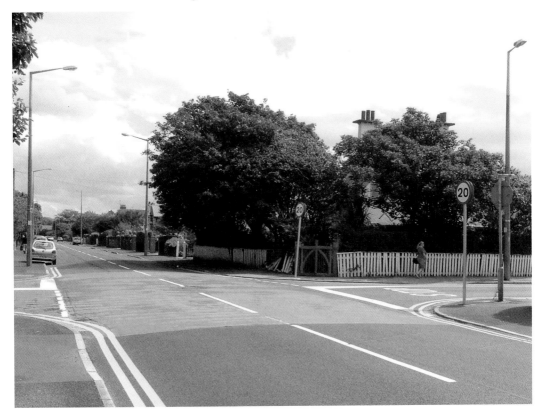

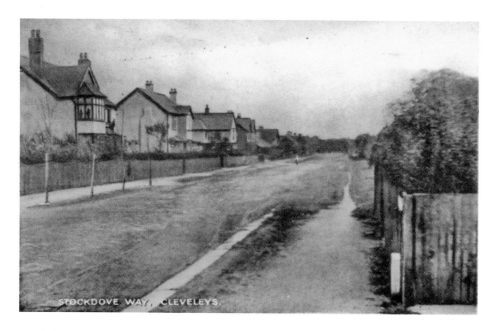

Stockdove Way

Stockdove Way was another road in the Cottage Exhibition that cut across Cleveleys Avenue. A cinder track before the exhibition, the area was a rural district for many years, but after the exhibition and the increase in population, the whole area soon disappeared under bricks and mortar. Both West Drive and Stockdove Way had vehicular access to Rossall Road but since the new multimillion-pound tram system was completed, Stockdove Way's access to Rossall Road has been blocked off.

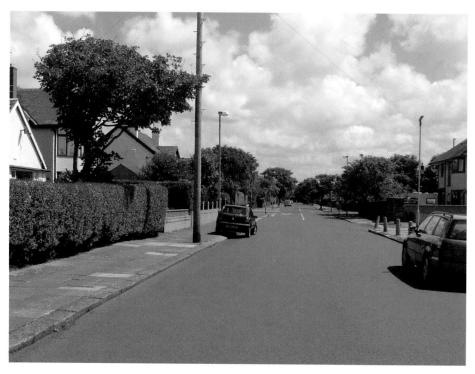

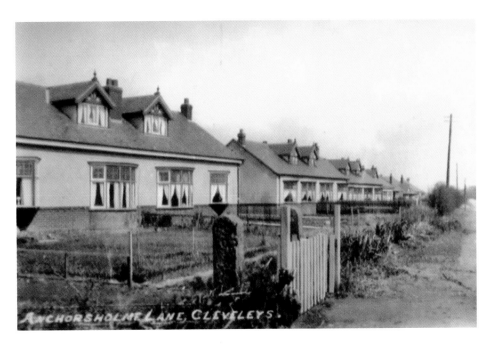

Anchorsholme Lane

Bungalows on an unmade Anchorsholme Lane, Cleveleys. The area looks out to the open countryside and Thornton beyond is waiting to be developed.

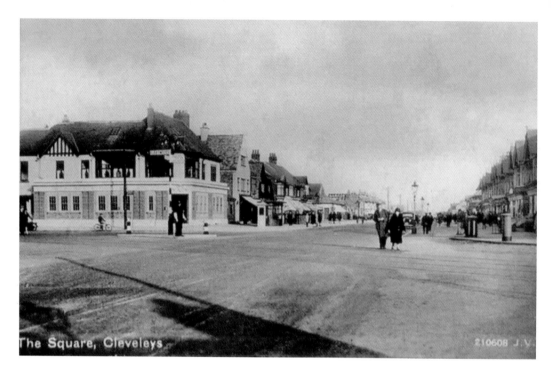

The Square, Cleveleys

The Square

Victoria Square looking down Victoria Road East to its distant junction with Amounderness Way, which continues to Thornton. The original road from Cleveleys seafront to Thornton was virtually straight until you met the country lanes round Thornton village. The new sculpture named *Sea Swallows* on Cleveleys seafront can be seen from the furthest point away, in a straight line along this road.

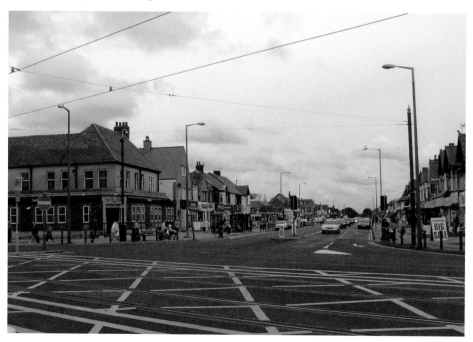

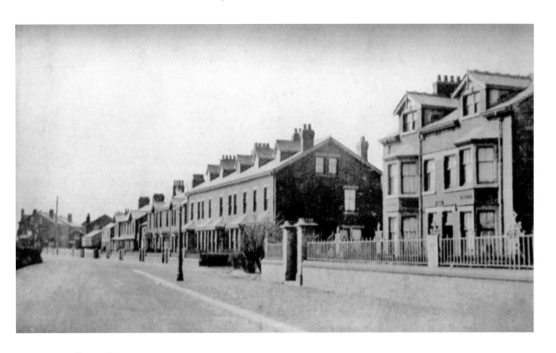

Rossall Road I

Looking south towards Cleveleys Square from Rossall Road, originally called Fleetwood Road. The road started as a narrow country lane in between hawthorn hedges and bushes that lead to Fleetwood. St Andrews church, situated on the corner of the Roughlea Road junction with Rossall Road, from roughly where the photograph was taken, was founded in 1910. The tower was added in 1930 and the baptistery, west end and west porch were added in the 1950s.

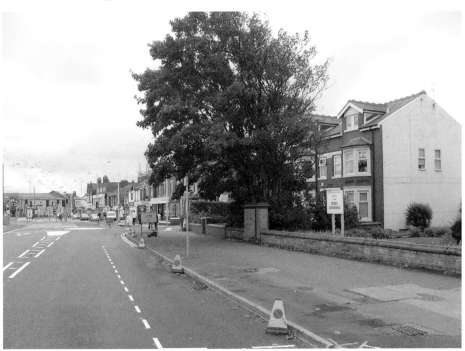

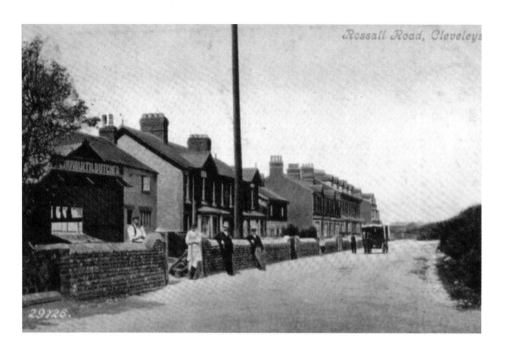

Rossall Road II

Some houses and shops on Rossall Road, as seen from the square looking north to Rossall. The properties were built from Cleveleys Square outwards. The property next to Forsyths was, before demolition, Howarth's Butcher's, next to which was Rowland View, built in 1896, followed by Willow Cottage, erected around 1780, which has now been painted white, followed by Windsor Terrace, built 1898, Werneth Terrace, built 1900, Fairfield, built 1903, and finally St Andrews church. founded in 1910 without a graveyard.

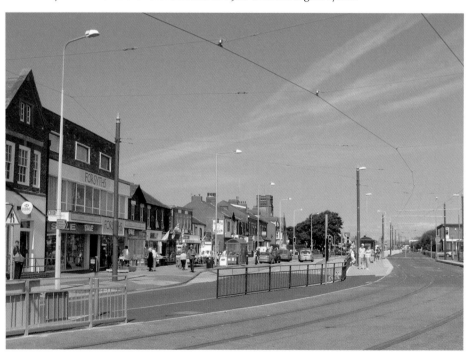

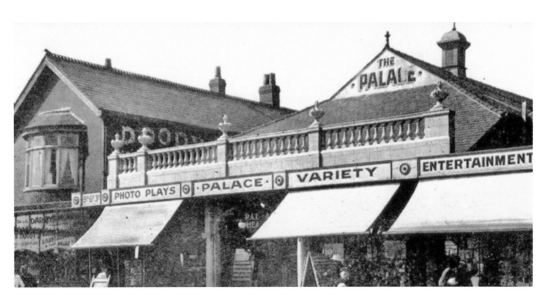

The Palace

An area of entertainment was to be found at the top of Victoria Road, at its junction with Princess Road, the Palace Variety and the Entertainment Centre. The Palace Variety had various fronts and uses over the years, as can be seen from the insets. Eventually it became the Savoy Cinema, with its lovely black and white frontage, seen in the left inset. This was unfortunately replaced with the dowdy frontage shown in the inset on the right. It later became a popular indoor market, which has now been closed.

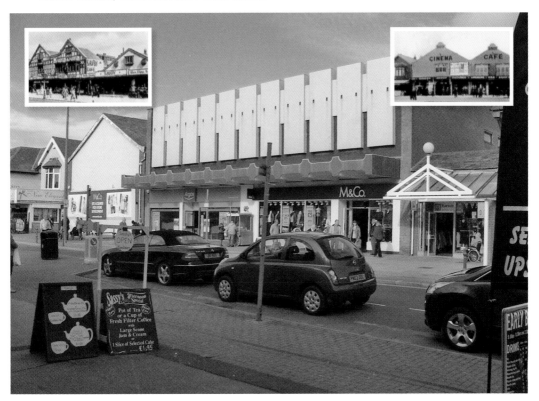

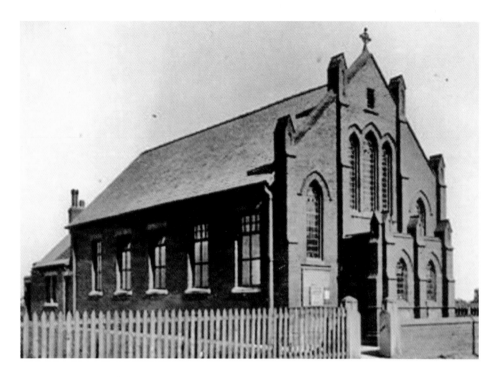

Cleveleys Congregational Church

The Congregational church was situated on the corner of Kensington Road and Beach Road, and served a small seaside community comprising of thatched cottages and farms. The parishioners complained, especially in the winter months when the winds and storms raged over the area. They struggled to get to the church, even with the aid of storm lanterns or candles in a jar, and they could not hear the sermons because of the noise of the weather. It later became a garage before it was eventually demolished.